IMAGES
of America

DORAVILLE

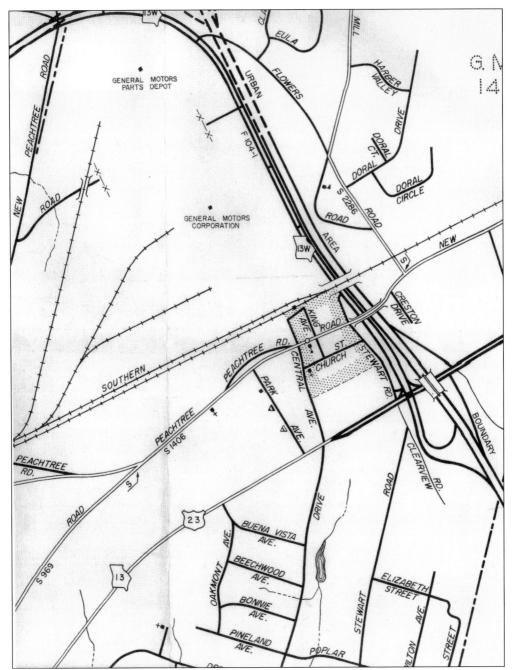

Construction of the General Motors plant and the new jobs that came along with it changed the face of Doraville forever. By 1960, when this map was made, new businesses and an influx of new residents in surrounding neighborhoods brought about more change in 15 years than in the previous 100 years. (Courtesy of Georgia Tech Library.)

ON THE COVER: When the first Doraville municipal swimming pool was opened in 1953, it created a perfect stage for local bathing beauty pageants such as this one, the 1955 Miss Juno Pageant. (Courtesy of Doraville Library.)

IMAGES
of America

DORAVILLE

Bob Kelley

ARCADIA
PUBLISHING

Published by Arcadia Publishing
Charleston, South Carolina

Printed in the United States of America

Library of Congress Control Number: 2012935931

For all general information, please contact Arcadia Publishing:
Telephone 843-853-2070
Fax 843-853-0044
E-mail sales@arcadiapublishing.com
For customer service and orders:
Toll-Free 1-888-313-2665

Visit us on the Internet at www.arcadiapublishing.com

*To Ed St. Amour for his daily support and encouragement,
and to my fellow members of the Doraville Breakfast Club—Ed,
Carol Gilman, Nancy Kelly, Terry Greenberg, and Jeff Jenkins—
for their encouragement and suggestions along the way.*

CONTENTS

Acknowledgments 6

Introduction 7

1. A Gentler, Simpler Time 9

2. A Community Becomes a City 19

3. How Great Thou Art 41

4. Pioneer Stock Produces Vibrant Citizens 51

5. A Sense of Community 71

6. Reading, Writing, and Arithmetic 83

7. General Motors Drives Growth in Doraville 101

8. Candid Doraville Then and Now 113

ACKNOWLEDGMENTS

First and foremost, I have to thank Doraville Public Library director Tammy Henry for suggesting that I do this photographic history of Doraville. Upon learning that I was a writer, she told me Arcadia Publishing was seeking someone to do the book, and the rest is history. Much valuable historical recall came from the minds and memories of John and Betty Maloney, John Creel, Boyce Creel, Harriet Leslie, Marie Creel, Mary Shue, Tommy Galloway, and William Spires, whose families played prominent roles in the growth and development of the city. Once the word spread that I was doing the book, one person would suggest I call another and another until I soon had a broad network of names of people willing to share their memories and photographs. Everyone helped, whether with photographs, information, or just a quick phone call to answer a question or two, and to them I am extremely grateful. Those folks, in no particular order, include: Merle Evans, Peter J. Roberts from the Georgia State University library, Kathy and Keith Fowler from UAW Local 10, Lou Jenkins, Alan Malcolm, Susan Fraysee, Doraville City Council member Maria Alexander, Harold and Sadie Roden, Connie Johnston, Bobby Lang, Eleanor Earley, Rick Dovi, Susan and Ben Crawford, Jim Draper, Donna Pelfrey Meyers, Greg Slater, Coni Binkley, Jim Pelfrey, Doraville mayor Donna Pittman, Andy Wallace at John Portman & Associates, Ann Crenshaw, Ernest Mastin, Roland Garner and Cathy Carpenter at the Georgia Tech Library, and Jennifer McDaid at the Norfolk Southern Corporation.

Others who provided invaluable assistance include Jennifer King, from the public relations department of Home Depot; Patty and Wayne Barker; the photographic archives of the DeKalb County Fire Rescue Department; Marvin and Emily Lyle; Buddy and Gloria Buie; Rebecca Crawford; Karin Johnson; Marlene Hadden; Laura Barre; Doris Roberts; Bobby Pittman; Camille McDougald; Chris Avers; Victoria Landis; Cindy Bradford; Bonnie Grey Flynt; Mike Gentry at NASA; and John Kyros at the General Motors Global Media Archive. Others who provided input include Terry Allen, Janice Fredo, Susan Barwick, Jeffrey Gentry, and Matt Farrell from Cary Reynolds Elementary School, and photographers Clyde May and Gabriel Benzur.

I am indebted to all of you, and I could not have made this book happen without your help.

I personally thank you, and Doraville thanks you.

INTRODUCTION

The 1830s proved an interesting decade in the United States and around the world. Economic prosperity spread across the United States under the administrations of Andrew Jackson and Martin Van Buren, railroad construction was expanding the American frontier westward, Charles Dickens was penning *Oliver Twist*, and Queen Victoria was on the threshold of her 63-year reign over the British Empire. In the American South, hardworking folks of English, Irish, and Scottish descent were migrating from Virginia and the Carolinas to neighboring southern states in search of a better life.

Some of the transplants who came to Georgia established an agricultural settlement that would one day become Doraville along a stretch of the Southern Railway on former Creek Indian lands. The early settlers were farmers, dependent not only upon agriculture but also on poultry and dairying. Large dairy farms covered land that was later sold and subdivided to create much of present-day Doraville. There are several legends that suggest how the community actually got its name, but the most widely accepted one is that it was named for Dora Jack, the daughter of a local Southern Railway official. This seems the most plausible tale because of the town's proximity to the railroad and its depot.

The first recorded activity in the Village of Doraville was the 1836 establishment of the Prosperity Associate Reformed Presbyterian Church, which became known as Doraville Associate Reformed Presbyterian in 1890. The church was founded by settlers with surnames such as McElroy, Stevenson, and Turner. Prosperity Associate Reformed Presbyterian and Prospect Methodist Church were the leading religious institutions in the city for years. Another important early settler was John Yancey Flowers, whose notable descendants included his son Dr. George Newton Flowers and his grandson Dr. John Ebenezer ("Eb") Flowers. The family has passed into history, but they played a huge part in the city's growth and prosperity for over a century as owners of land including the area that would become downtown Doraville.

The village did not grow much in the years before the Civil War, which, as in many regions of the South, left the countryside around Doraville turned upside down. After the war, the hardship was such that local residents were starving. Women cleaned feed bins of stables and barns to gather grains of corn for their children. Even though the people suffered, they steadfastly remained in the area to continue the efforts of their forefathers to forge a new town. By the time the city of Doraville was incorporated on December 15, 1871, nearly 150 residents lived in the area. For the next 50 years, limited growth occurred as people tilled the rich red soil, milked their cows, and made a living off the land any way they could. Doraville quietly existed for years as an exemplar of small-town rural America, with residents experiencing their everyday lives, creating churches, building schools, and establishing small businesses.

In 1942, DeKalb County built a massive water plant in Doraville, and that feat was a major factor in General Motors Corporation's decision to build a huge automobile assembly plant in Doraville in 1947. Additionally, Doraville served as the home of the Plantation Pipeline Company, which

operated a pipeline system that ran from Baton Rouge, Louisiana, through Doraville and into Greenville, South Carolina. During World War II, the pipeline played a primary role in moving oil through the southeastern United States while oil tankers in waters off the East Coast were under the threat of enemy attack. The pipeline led to the establishment of a number of well-known local tank farms, where oil companies still store product today.

With the arrival of General Motors and the tank farms, Doraville saw more growth in 15 years than it had experienced in the previous 100 years. GM brought thousands of new workers to the area, creating a need for new neighborhoods, shopping centers, and other businesses necessary for a growing, thriving community.

Today's Doraville is a blend of many things, including industry, diversity, historic neighborhoods, and opportunity. Within its 3.6-square-mile boundary, rich ethnic diversity has redefined the area. DeKalb County's "International Village" in Doraville contains numerous businesses aimed at Spanish, English, Korean, Vietnamese, Muslim, Arabic, Chinese, and other cultural audiences. Together, the various cultures work in harmony to create 21st-century Doraville.

A major factor in the city's success, which has shown itself time and again in researching this book, is the spirit of the people of Doraville and their individual histories. Many still live in their original homes in neighborhoods like Northwoods and Oakcliff.

Others have gone on to higher recognition. There is John Casper, who lived in Doraville, attended Chamblee High School, and went on to pilot space shuttles *Atlantis* and *Endeavour*. Members of the Atlanta Rhythm Section (ARS) got their start in a Doraville recording studio called Studio One and gained fame on the national pop-rock scene much like contemporaries Lynyrd Skynyrd and the Allman Brothers. ARS producer/manager Buddy Buie, who cofounded Studio One, achieved fame writing hits like "Traces," "Stormy," and "Spooky," and once served as Roy Orbison's road manager. Boxing great Evander Holyfield trained at Doraville's Paul Murphy Boxing Club (then known as the Doraville Boxing Club).

The local people working and achieving under the radar have helped to create the core essence of the city. Doraville stonemason Byron Walter helped build the base for a Centennial Olympic Park sculpture in downtown Atlanta that symbolizes the first Olympic Games. Using limestone from the centuries-old stadium in Olympia, Greece, for the base of the sculpture, Byron and his brother, Keith, became the first people in the United States to ever set stone gleaned from the original Greek Olympic stadium. Frank Brooks, from the Winters Chapel Road area, was the state grand champion in the Georgia Truck Driving Championships in 2001. Oakcliff country songwriter Margaret Maurer wrote music that was recorded by Ray Stevens, Pam Tillis, and other stars of the country music world. Phuong Phuong Tang participated in the US Open Table Tennis Championships in Las Vegas in 1983, and Dave Albee from English Oak Drive received funding from the city to display his woodcarvings at the 1982 World's Fair in Knoxville, Tennessee. In 1983, wooden carved panels by Virgil Cavender were featured in the state capitol building in Atlanta.

These folks, and many others like them, are just a few of the Doraville residents who helped the city sprout from a huge tract of dirt roads and woodlands. Similar families and individuals are highlighted throughout this book to honor their contributions to the city.

There is an old saying that says, "to Southern people, where we came from is part of who we are." This best describes the legacy of Doraville and the people who played a role in shaping the face of the city as we know it today. Space limitations do not allow for the inclusion of every piece of information or all of the more than 500 photographs collected while assembling this book. However, great efforts have been made to give a balanced, fresh look at the people of Doraville, where we have been, and where we are headed.

Enjoy!

One

A GENTLER, SIMPLER TIME

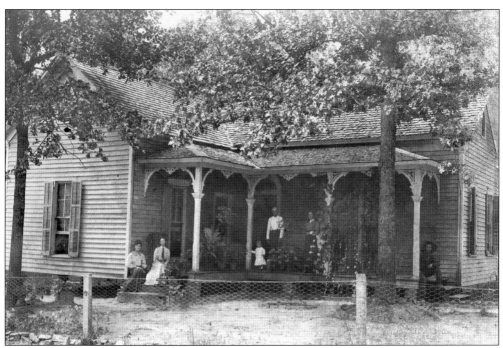

The Gregory-Galloway house, built around 1883, is still home to members of the Galloway family. The house was built by David Alexander Chesnut for his wife, Sara Elizabeth (Sally), and still retains its original 12-foot ceilings, heart pine plank floors, and, in some rooms, original wainscoting or paneled walls. The original Galloway farm covered 100 acres, but only about two and a half acres remain under Galloway control today. (Courtesy of Tommy Galloway.)

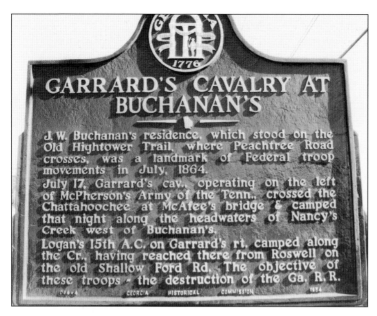

This Georgia historical marker is located on Buford Highway in Doraville near the Gwinnett County line. It commemorates the encampment of Union troops bent on destroying the Georgia Railroad during the Civil War. The marker was placed near the site of the J.W. Buchanan residence that was built where the Old Hightower Trail intersected with Peachtree Road. (Photograph by Bob Kelley.)

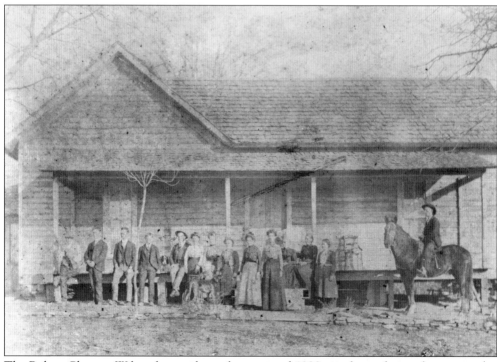

The Robert Chesnut Wilson home, shown here around 1900, was located near the present-day Winters Chapel Road site of the DeKalb County Department of Watershed Management. Wilson ran away to fight in the Civil War and was sent home when it was discovered that he was not old enough to join the ranks. The war was still raging when he did reach the appropriate age, and he returned to fight for his beloved Georgia. (Courtesy of Harriet Leslie.)

The Chesnuts were a prominent founding family of Doraville, and they intermarried with the Wilson, Tilly, Medlock, and Gregory families. George Robert Chesnut (pictured at right) was a great-uncle to Doraville residents Tommy and George Galloway. He was born on April 8, 1843, and is believed to have died in the Civil War in Richmond, Virginia, on July 6, 1862. He is listed on the muster roll for Company A, 38th Georgia Regiment in the Confederate Army. (Courtesy of Tommy Galloway.)

Robert Chesnut Wilson and his wife, Henrietta Eidson Wilson, are pictured below in later years. The two early residents of Doraville were farmers. Their daughter, Maebelle, married John Calvin Leslie, and they had a daughter, Harriet Leslie, who has been active in local Associate Reformed Presbyterian Church circles as a choir director and church organist. (Courtesy of Harriet Leslie.)

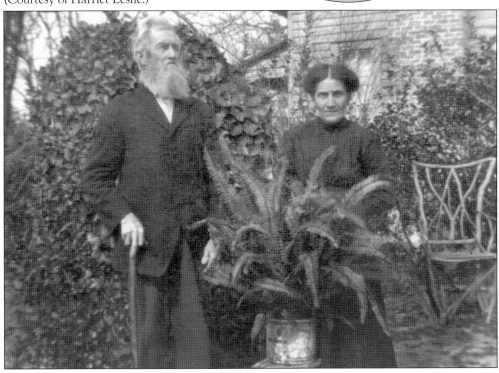

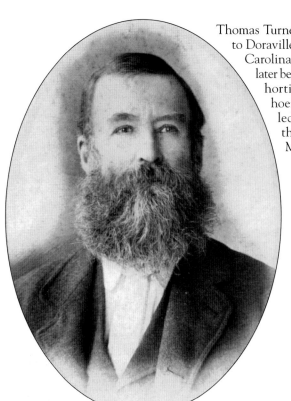

Thomas Turner Stewart was born in 1848 and moved to Doraville in 1884 from Anderson County, South Carolina. He bought 160 acres along what would later become Stewart Road. A farmer and talented horticulturist, he was hit in the eye while hoeing his garden, and the injury eventually led to blindness. His progeny produced the prominent Creel family. (Courtesy of Mary Shue.)

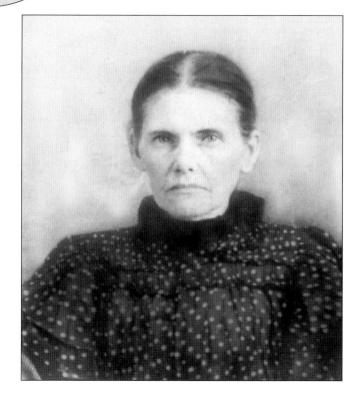

Mary McCurry Stewart, Thomas Stewart's wife, worked on the farm and helped raise the children. The couple's log cabin was built on a 160-acre spread, and the farm's northern property line later formed the northern border for Northwoods neighborhood. (Courtesy of Mary Shue.)

John W. Munday and his wife, Alice, are pictured at right after their wedding on February 22, 1892. John Munday was born on March 13, 1859. His grandfather Coleman B. Monday was born in 1796 in Virginia. As often happened in the days of early record keeping, last names would often be misspelled. Somewhere along the way, Monday became Munday. Below, John and Alice are pictured at their home on Church Street where they raised their children Dura, Clifford, Ruth, Ella, Margaret, and Floyd. (Both courtesy of Connie Johnston.)

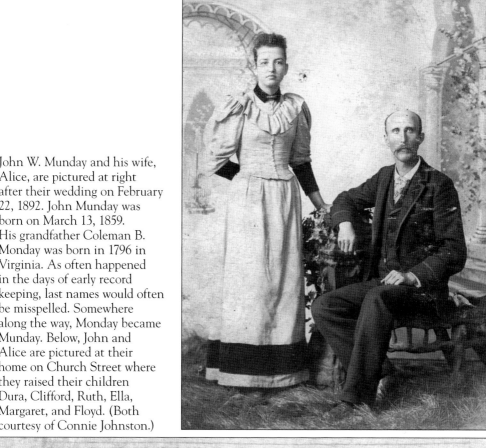

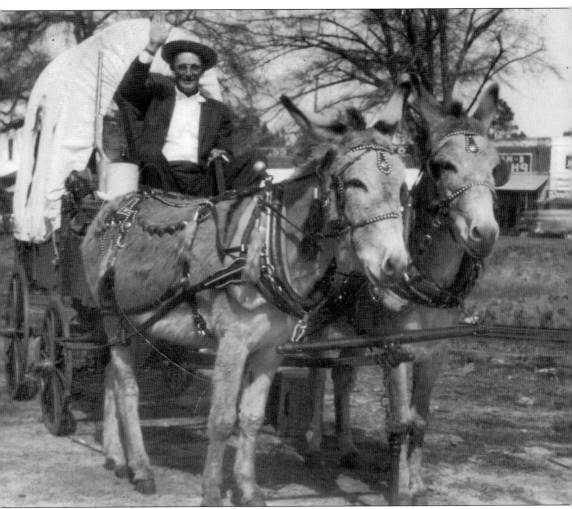

Into the early 20th century, covered wagons and mules were still a common mode of transportation in some of the more rural Georgia communities and towns. Here, Vincent Sims, father of longtime Northwoods resident Corinne Sims Lang, waves from his covered wagon. Corinne's family hailed from the rolling Appalachian foothills of North Georgia, where they raised animals and had a cotton farm. Before she died in 2011, Corinne often recalled happy childhood memories such as riding to the store with her grandfather in his covered wagon. Corinne moved to Northwoods in 1954 and was active in many Doraville and Northwoods civic projects. Her husband, Lamar, served on the Doraville City Council. (Courtesy of Bobby Lang.)

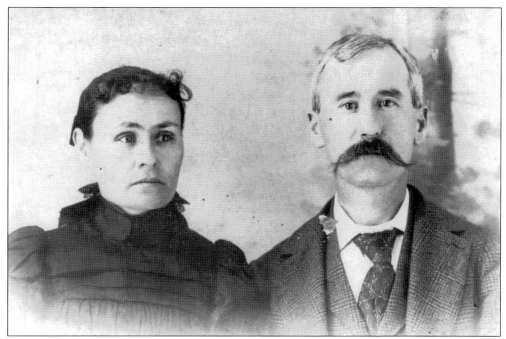

Joseph Edward Munday, pictured with his wife, Emma Dodds Munday, moved the Munday family to Doraville from Milton County, Georgia, in the late 1800s. He and his brother, John, had a store known as Munday Brothers, located on New Peachtree Road at King Avenue, that operated until 1912 before a name change to J.W. Munday and Company. Joseph and Emma, who married in 1897, purchased their home on New Peachtree Road for $250 in 1898. (Courtesy of Donna Pelfrey Meyers.)

Corinne Sims Lang (left) sits in her grandfather's pasture with childhood friend Edward Hulsey. This photograph was taken in the early 1930s; note the old Model T cars in the background. Lang moved to Doraville as a youngster, married at 17, and worked at Kay Jewelers for many years. (Courtesy of Bobby Lang.)

Willis Russell Gregory and Susan Blanche Chesnut—pictured with their two daughters, Betty (left) and Virginia—were married in 1914. Gregory, a resident of Kershaw, South Carolina, worked in a cottonseed mill there, and his family ran a boarding home where Chesnut rented a room. Gregory lost his left hand and his right thumb in a mill accident but was still able to shave and perform other everyday activities. After moving to Doraville, the couple lived with her parents in the family home on Tilly Mill Road—about 100 acres used primarily for raising staple Southern crops of cotton and corn. At one time, he also worked for the Commercial Envelope Company in Atlanta. (Courtesy of Tommy Galloway.)

Lucile Munday, daughter of Joseph E. and Emma Munday, was born in 1899 at 6110 New Peachtree Road in Doraville. She eventually married William "Willie" Pelfrey, who owned Pelfrey Feed and Grocery. A member of Doraville Associate Reformed Presbyterian Church for 80 years, she was known as Doraville's "Grand Old Lady" by the time she died in 1989 at age 90. (Courtesy of Donna Pelfrey Meyers.)

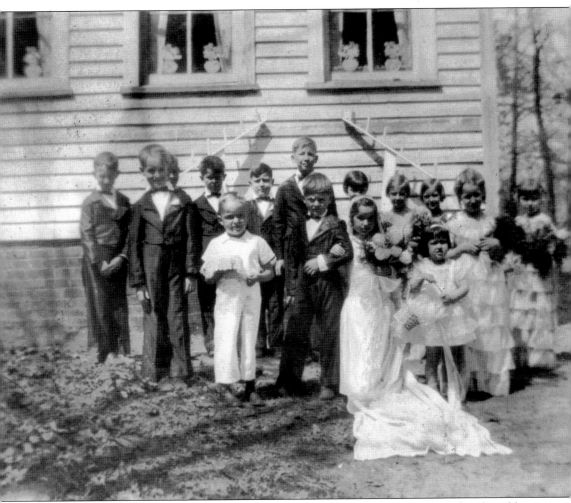

In this 1933 photograph taken at the old Doraville School, the bride at the Tom Thumb wedding was Virginia Gregory (Tommy Galloway's mother), and Boyce Creel was the groom. Both came from prominent Doraville pioneer families. This popular type of children's pageant was named for Charles Stratton (better known by his stage name, Tom Thumb), a little person who performed in P.T. Barnum's circus. Stratton married a fellow little person, Lavinia Warren, on February 10, 1863, in an elaborate ceremony in New York City. In a Tom Thumb wedding, the roles of the wedding party were played by small children, usually under 10 years old. Children were assigned to portray the bride, groom, attendants, and sometimes the minister. Smaller children served as flower girls and ring bearers, and everyone was dressed in traditional adult wedding apparel. Churches, schools, and various organizations held Tom Thumb weddings as youth activities in the days before television. At the conclusion of the ceremony, the bride and groom were often pronounced "playmates for life." (Courtesy of Tommy Galloway.)

Virginia Gregory was the daughter of Susan Blanche Chesnut and Russell Gregory. She attended Oglethorpe and Georgia State Universities and, in 1950, married Doraville hardware store owner George Galloway. The Galloways were prominent business and civic leaders in Doraville for the next four decades. (Courtesy of Tommy Galloway.)

Susan Blanche Chesnut Gregory is pictured on the front porch of the Gregory-Galloway home with her daughters, Virginia (left) and Betty. Susan's parents, David and Sarah Chesnut, moved to the Doraville area in the late 1800s and farmed 100 acres on Tilly Mill Road. (Courtesy of Tommy Galloway.)

Two

A Community Becomes a City

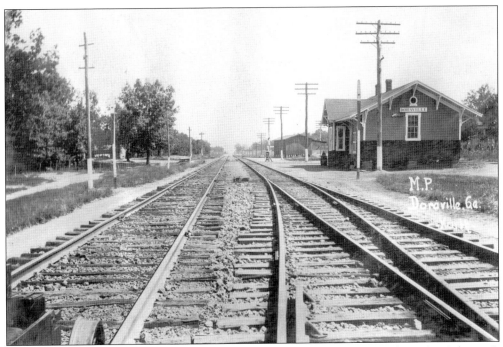

The original Doraville city limits were one-half mile in every direction from the Atlanta & Richmond Air-Line Railway depot, shown here in 1919. Construction of the railroad was delayed by the Civil War and resumed in 1869, two years before Doraville was incorporated. Extending from Charlotte, North Carolina, through Doraville and Atlanta to New Orleans, the railroad became a vital part of the Southern Railway (later Norfolk Southern) network in 1894. (Courtesy of Norfolk Southern.)

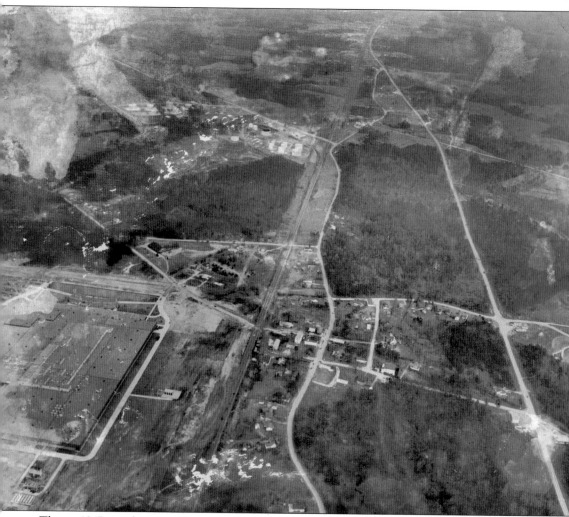

This c. 1947 aerial view of Doraville shows the extent to which the city was gradually making the transition from rural community to small urban city. The opening of the General Motors plant on June 15 and 16, 1947, opened the floodgates for residents buying homes in the Tilly Mill, Oakcliff, Gordon Heights, Guilford Village, and Northwoods neighborhoods, which helped to spark the creation of new businesses. Restaurants, department stores, banks, small shops, groceries, and even movie theaters became the face of Doraville for the next 50 years. Note that the GM plant's parking lot (far left) is not yet paved. (Courtesy of John Maloney.)

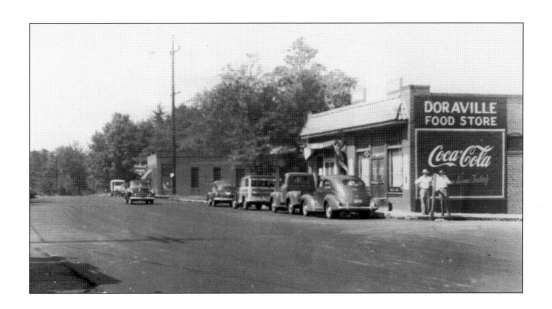

These images show downtown Doraville as it looked around 1949. The photograph above is of the Doraville Food Store, which was one of the town's main grocery stores and was owned by Floyd Munday. The building pictured below, which was located on the west side of New Peachtree Road, housed a number of businesses, including a dry goods store, Epps Barber Shop, the medical office of Dr. John Ebenezer ("Eb") Flowers, and the Doraville Post Office. It was once one of the oldest buildings in Doraville, but was torn down when construction began on the Metropolitan Atlanta Rapid Transit Authority (MARTA) Doraville station complex. Dr. Flowers, a major city benefactor and landowner, owned the building and was also one of Doraville's earliest postmasters. (Both courtesy of John Maloney.)

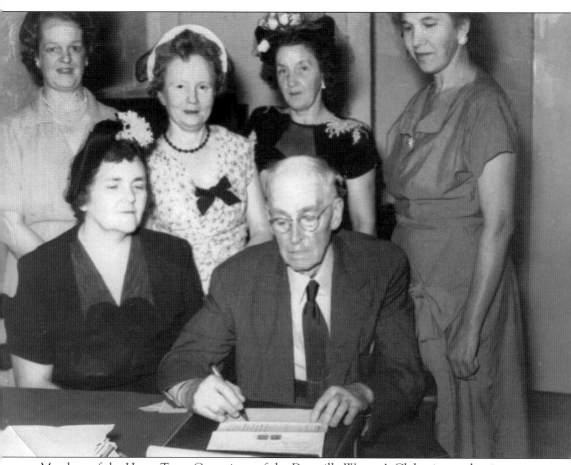

Members of the Home Town Committee of the Doraville Women's Club witness the signature of Dr. John Ebenezer ("Eb") Flowers in 1950 as he deeds a tract of land—which would later be known as Flowers Park—to Doraville. Pictured here are, from left to right, (first row, seated) Roxie Epps and Dr. Flowers; (second row, standing) Lois Smith, Malcomb Bracewell, Linda Spires and ? Shirley. The text of the deed began, "For and in consideration of my love and affection for my neighbors and fellow citizens and pride in my community." Dr. Flowers descended from a prominent Doraville pioneer family that owned much of the property that became downtown Doraville. His home, where he lived into old age with his sister, Daisy, was located on Buford Highway near the present-day location of the Buford Highway Farmers Market. It was torn down in the mid-1960s to make way for a Treasure Island (discount retailer owned by JC Penney) store. Dr. J.E. Flowers' great-grandfather was Maj. John Y. Flowers, who was named postmaster of Cross Keys on May 12, 1852. Major Flowers was a member of Company A, 39th Georgia Volunteer Regiment, known as the Murphy Guards, which went to the Civil War on September 26, 1861. (Courtesy of William Spires.)

William "Willie" Pelfrey and his wife, Lucile, owned the Pelfrey Feed and Grocery store and mill in Doraville. Next door to the store was the house where they raised their three children—Hugh, Harold, and Grace. Willie and Lucile Pelfrey were grandparents of Donna Pelfrey Meyers. (Courtesy of Donna Pelfrey Meyers.)

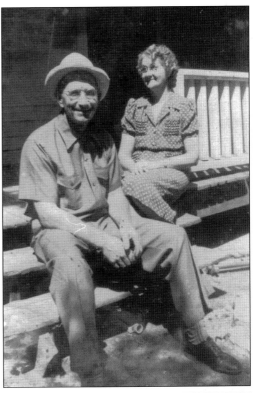

The William T. Pelfrey Feed and Grocery, located in the Flowers and Tilly Mill Road area north of downtown Doraville, was a popular place to buy groceries, canned goods, seed, gasoline, and the old Southern standby—RC Cola and a MoonPie. Many locals remember the big glass display case featuring 5¢ candy bars and 6¢ bottles of Coca-Cola for sale there, too. The Pelfreys' gristmill, located next door, provided ground cornmeal for bread, biscuits, and corn bread before the advent of mixes like Bisquick made cooking with fresh cornmeal seem archaic. (Courtesy of Doraville Library.)

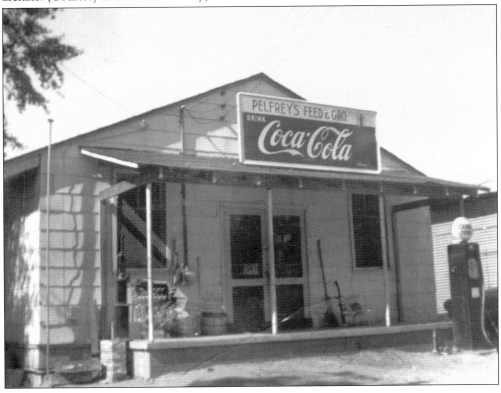

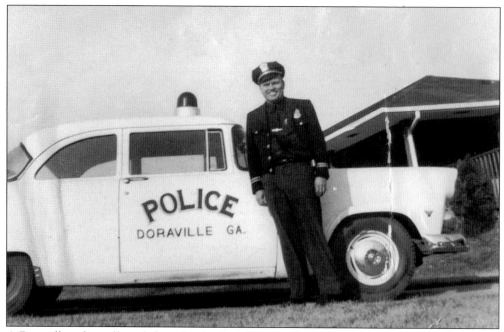

A Doraville police officer, believed to be Carl Christian, stands in front of his new police car in 1955. The new Ford replaced a unit that was wrecked while chasing a suspected whiskey car. The police vehicle, painted black and white, featured a dome light and was equipped with the latest police radio technology. (Courtesy of Doraville Library.)

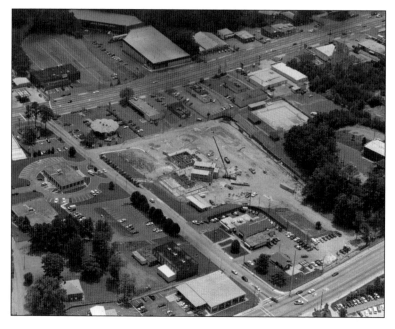

A 1998 aerial view of downtown Doraville shows city hall in the upper left and the Doraville Library just below it. At right, the Doraville Police Department complex is under construction on a portion of Flowers Park. The public swimming pool, which replaced the one built in 1953 in another section of the park, is visible in the upper right corner. (Courtesy of Doraville Library.)

Buford Highway (State Route 13), pictured around 1978, has become a highly developed commercial corridor that runs through the heart of Doraville. This view is looking north from just outside Interstate 285. Unlike many of the streets in Doraville, which were built over original pioneer trails and Indian paths, Buford Highway was constructed along an entirely new route to meet the growing needs of the city. (Courtesy of Merle Evans.)

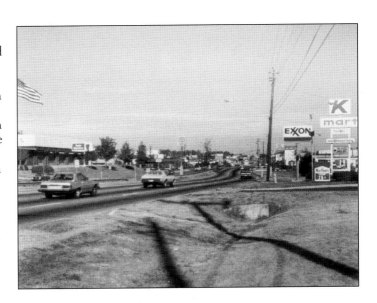

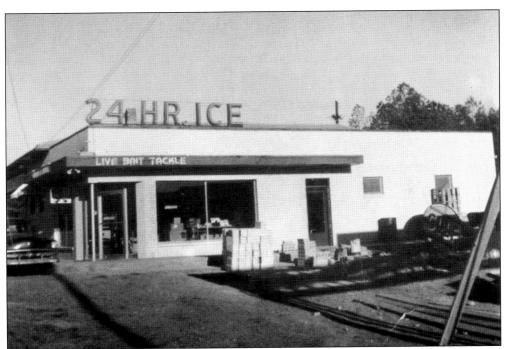

Goree Ice Company, a Doraville landmark for decades, was located at the corner of Chestnut Drive and Buford Highway. Built in 1946, it specialized in crushed and block ice. In 1967, a convenience store, gas pumps, and fishing and bait supplies were added, prompting a change of name to Angler's Corner. The nonautomated ice plant produced 17 tons of ice every two days, and much of the block ice was sold to restaurants and hotels for ice carvings. Eventually, the business produced gourmet crushed ice with all chemicals and impurities removed. (Courtesy of John Maloney.)

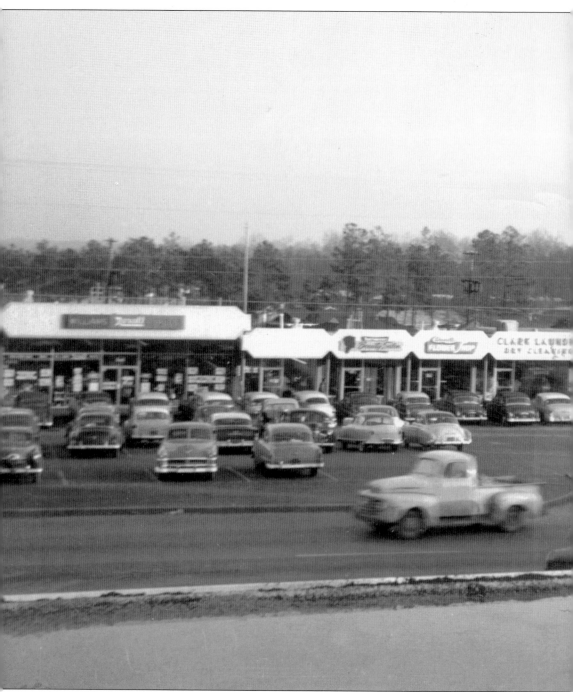

Boasting "every convenience for shoppers," the Northwoods shopping center was built on Buford Highway in 1955 to anchor the northwestern border of Northwoods neighborhood. The center was developed by Lowell Dowdell and Walter L. Tally, developer of Northwoods subdivision, and was an integral selling point for those interested in buying homes in that neighborhood. The property offered enticing frontage on both Shallowford Road and McClave Drive. The shopping mecca, which cost $350,000 to build, was Doraville's first complete retail unit and opened with

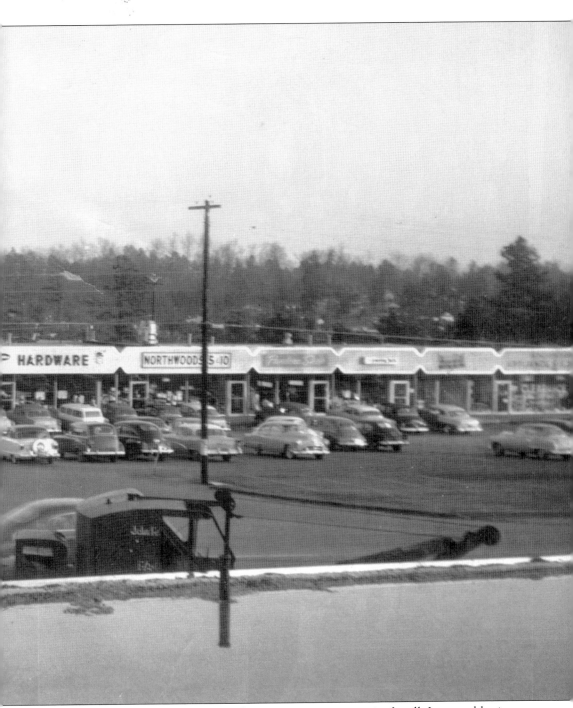

a flourish of speeches, band music, and commemorative souvenirs for all. Inaugural businesses occupying the center included Big Apple Super Market, Pandora Dress Shop, Williams Rexall Drug Store, Northwoods 5 and 10, Clark Laundry and Dry Cleaning, Northwoods Beauty Salon, Henderson's Hardware, Doraville Flower Shop, Northwoods Barber Shop, and Jumping Jack Toy Shop. (Courtesy of Doraville Library.)

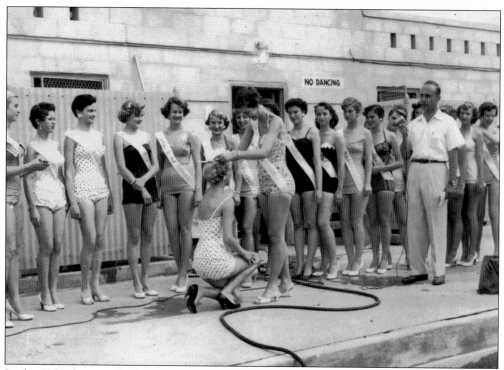

In the 1955 photograph above, Beverly Prator of Brookhaven is being crowned Miss Juno at the second annual Juno Festival at Doraville's Flowers Park swimming pool. Presenting the crown is Nancy Cowan, the previous year's winner. The festival was sponsored by the North DeKalb Teen Club, which sponsored various civic activities and projects for the city, including construction of a commemorative bench placed near the pool. The annual Juno Festival featured a beauty pageant, a barbecue, and an aquatic show. The Doraville swimming facility was the first of two built on the park site. This original pool, built in 1953, was located near where the Doraville Police Department complex is today. (Both courtesy of Doraville Library.)

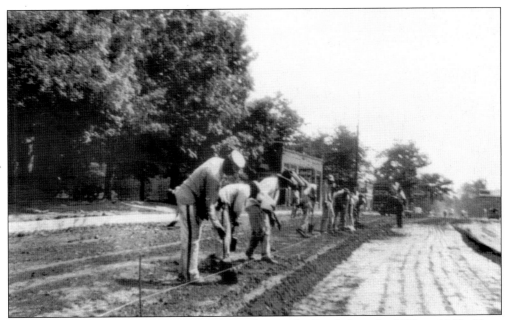

Using convicts, or "chain gangs," was commonplace in the South from the 1930s to 1960s. Here, prisoners are hard at work, helping to expand Peachtree Road in Doraville in the 1940s. DeKalb County used prison labor until local contractors, capable of doing much of the work, complained they were losing money by not being hired to do the work the prisoners were doing. (Courtesy of John Maloney.)

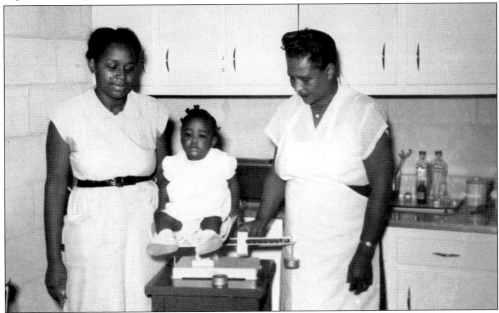

In this 1955 image, local citizens visit the Doraville Health Center, which was located at 3760 Park Avenue and operated by the DeKalb County Board of Health. The center offered maternal and child care, vision and hearing screenings for preschool and school children, sports physicals for schools, family planning, immunizations, and premarital blood testing, among many other services. (Courtesy of Doraville Library.)

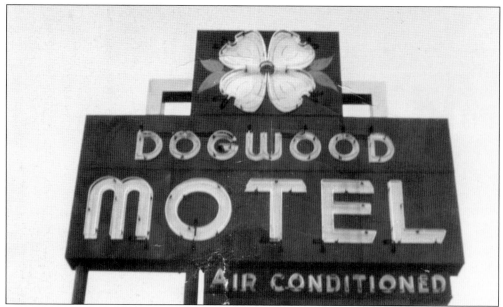

Once the only motel in Doraville, the Dogwood Motel was a city landmark until it was demolished in the early 2000s. The multiunit motel was located on Buford Highway near McClave Drive. Next door was a restaurant that served excellent meals every day, but was a particularly popular gathering place for Sunday lunch for the after-church crowd. (Courtesy of Doraville Library.)

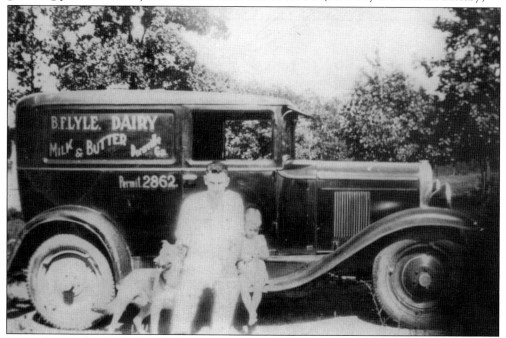

Doraville got its start as an agricultural community that included numerous dairy farms. One such farm was the 10-acre B.F. Lyle Dairy on Woodwin Road. The dairy sold buttermilk and butter to customers in Buckhead, Brookhaven, and Chamblee, as well as Doraville. Here, B.F. Lyle sits with his son, Frank, on the running board of his dairy farm's delivery truck. (Courtesy of Marvin Lyle.)

In 1950, Dr. John Ebenezer ("Eb") Flowers and Ed. S. Grant, an Atlanta businessman, donated eight acres of land between Peachtree Road and Buford Highway, in the center of Doraville, to be converted into a city park. The Doraville Women's Club took an active role in the development of the project; various fundraisers were held to earn money for their activities, including street dances and a cooking school. (Courtesy of Doraville Library.)

New officers of the Doraville Women's Club are pictured at their installation on March 10, 1949. They are, from left to right, (first row) ? Oglesby, ? Todd, Malcomb Bracewell, and president Lillie Grant; (second row) Lucille Medlock, Flora Miller, Linda Spires, and Roxie Epps. (Courtesy of Doraville Library.)

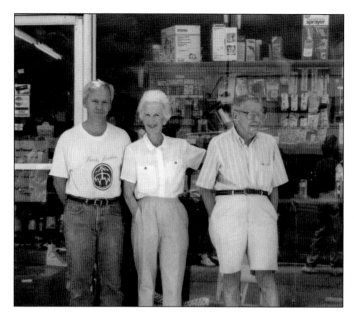

Hardware store owner George Galloway (right) is pictured with his wife, Virginia, and son, Tommy, in 1996. George opened Galloway Hardware on New Peachtree Road in 1946, when Doraville was a city of only 450 people. The business specialized in gardening equipment, seeds, paints, and electrical and plumbing supplies. The store prospered with the arrival of the General Motors plant in 1947, and the closing of the GM plant nearly 60 years later helped lead to the hardware store's closure. (Courtesy of Merle Evans.)

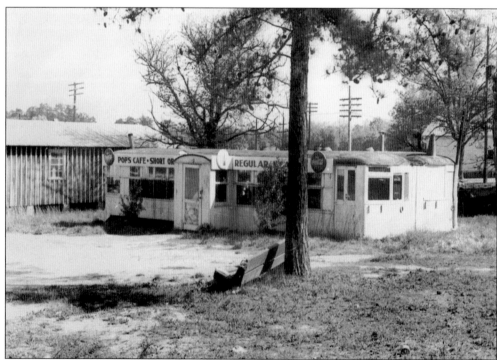

Pop's Cafe, also once known as Two Bell Diner, was a Doraville novelty in 1939. Built from two renovated streetcars (thus the name "two bell"), it was owned by Jack Cox. The diner was located in downtown Doraville next to the bowling alley (visible in the background at left), where local youngsters would set up pins for Depression-era wages of 2.5¢ per game. Foster Wiley ran the bowling alley for the Doraville Men's Club. (Courtesy of William Spires.)

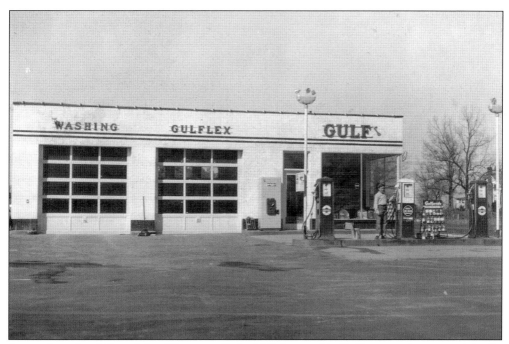

Located north of Goree's Ice House on Buford Highway, this Gulf gas station was originally owned by Harold Humphries. Ownership was later taken over by Lamar Nelson. (Courtesy of Doraville Library.)

The Carver Hills Civic Club was organized in 1954 with the help of the Doraville Women's Club and other local civic groups. The club members shown at right are unidentified, but Hubert Hood was the first president of the group, and other officers included Sam Ralston, first vice president; Sam Daniel, second vice president; Minnie Walker, recording secretary; Essie Johnson, corresponding secretary; and William Hood, treasurer. (Courtesy of Doraville Library.)

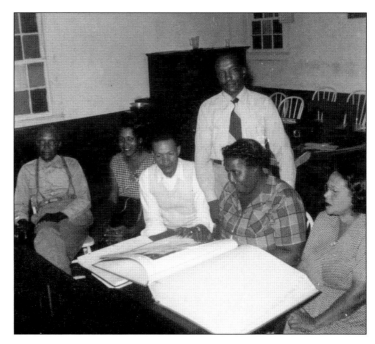

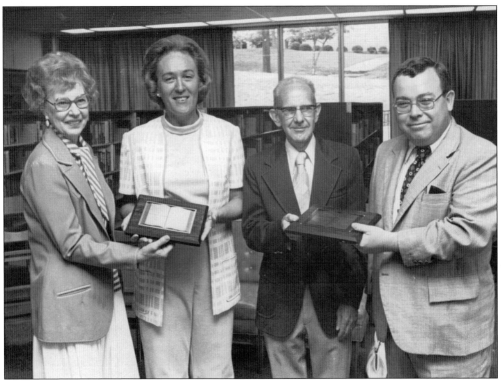

Doraville Library board members pose during a special ceremony in August 1975. Pictured here are, from left to right, Florence Leonhard, librarian; Mildred Fadden, former chairman and member emeritus; Francis Allison, member emeritus; and Robert J. Thomas, board chairman. (Courtesy of Doraville Library.)

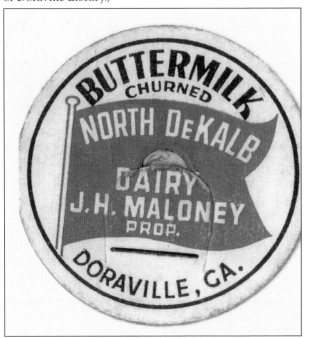

This is a nostalgic reminder of the days when glass-bottled milk was delivered house to house by local dairies. This cardboard plug, inserted in the cap of the milk bottle, belonged to the J.H. Maloney Dairy, which was located where the General Motors plant was eventually built. (Courtesy of John Maloney.)

Clyde Spires christens the new Doraville Post Office in 1949. The postal service played an important role in the Spires family. Clyde took over as postmaster after Dr. John Ebenezer ("Eb") Flowers retired in 1940. Clyde's son, William "Bill" Spires, worked in the post office at its next location, on New Peachtree Road, and retired in 1983. (Courtesy of William Spires.)

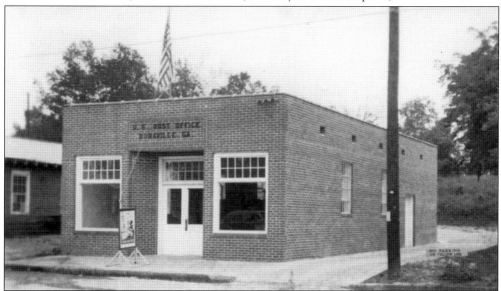

Located on New Peachtree Road, this was the third Doraville post office building. The original, built during the Civil War, was replaced by one in an office building in downtown Doraville, and it, in turn, was replaced in 1949 by this larger, more modern structure at a cost of $9,000. Postal receipts were considered a measure of growth for a city, and in 1946 they were $594. After the 1947 construction of the General Motors plant, they grew to over $6,000 by the end of 1947 and doubled to over $12,000 in 1948. (Courtesy of Doraville Library.)

$1.00

DORAVILLE CENTENNIAL PROGRAM

1871 — 1971

CO-SPONSORED BY THE CITY OF DORAVILLE AND THE DORAVILLE JAYCEES

In 1971, from September 11 to September 18, nostalgia ruled and hometown pride exploded as Doraville citizens celebrated the city's 100th birthday. State and local politicians, local celebrities, and business leaders were on hand for the centennial celebration that included parades, Western music, an arts and crafts festival, barbershop quartets, a baking contest, rock concerts, a "best beard" contest, a greased pig chase, and greased pole climbing. Members of the Doraville Jaycees, wearing large white cowboy hats, served as city ambassadors, mingling among the centennial throngs to answer questions. The weeklong event ended with a spectacular fireworks celebration. The 1870 census showed fewer than 150 residents in the city, while the 1970 census listed 9,139 residents, making Doraville the third largest municipality in DeKalb County at the time. (Courtesy of Doraville Library.)

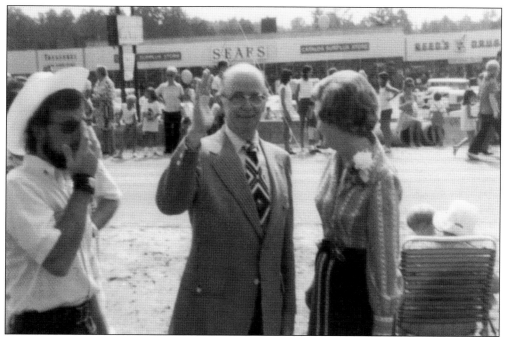

Georgia governor Lester Maddox (above, center) took the time to attend Doraville's centennial parade in 1971. Georgia's 75th governor, who served from 1967 to 1971, was known for his inflammatory segregationist views; in 1977, while suffering financial problems, Maddox tried a short-lived nightclub comedy act with African American Atlantan Bobby Lee Sears. The grand marshal of the centennial parade was Rico Carty of the Atlanta Braves, and vintage horse-and-buggy wagons (below) were used to transport some of the parade's participants. (Both courtesy of John Maloney.)

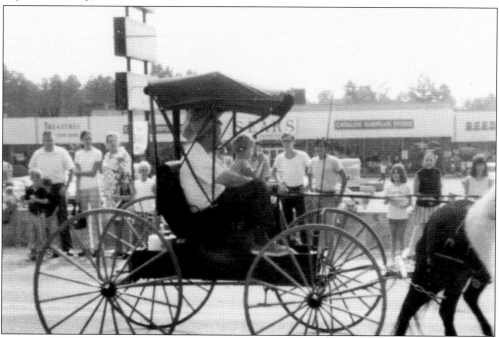

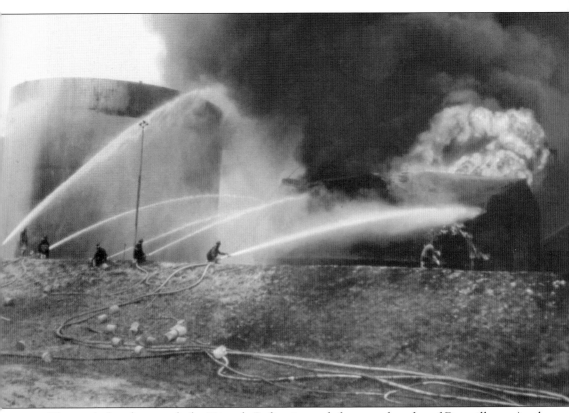

The tragic fire that struck the Triangle Refineries tank farm on the edge of Doraville on April 6, 1972, remains one of the most infamous incidents in the city's history. In the predawn hours, an overfilled tanker truck at the gasoline storage plant sent fumes floating though the nearby Doral Circle/Moon Manor neighborhood, where they ignited after coming into contact with a residential home's furnace pilot light. The home exploded, creating an inferno and killing the home's resident, James Sloan Jr., and refinery worker Eustace Smith. Flames consumed several of the huge tanks that contained gasoline and kerosene. The inferno burned for nearly four days, causing the evacuation of nearly 300 homes, and some claim the plumes of smoke could be seen as far away as Alabama. The flames were so intense that the huge round metal tanks turned red and collapsed, the red light on a fire engine melted, and fire hoses burst. Flames leaped more than 200 feet into the air while firemen crouched just 20 yards away, spraying water, then foam, then back to water. The firemen hosed each other regularly as protection against the heat. (Courtesy of DeKalb County Fire Rescue.)

Ironically, a preplanning manual issued as a guide to fighting tank farm fires in the Doraville area had been published just three weeks before the Triangle Refineries accident; it was useful in helping to get the fires under control. The cost of damages from the fire (pictured above and below) climbed into the millions of dollars for Triangle, not to mention the three homes that were completely destroyed and six others that were damaged. Only nine months later, on Christmas Eve in 1972, another gas explosion rocked the Triangle Refineries, killing foreman Kenneth Womack. The fire was quickly brought under control. Both incidents resulted in an intense safety campaign spearheaded by oil companies and public safety officials. (Both courtesy of DeKalb County Fire Rescue.)

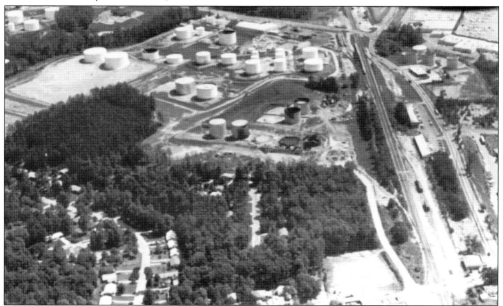

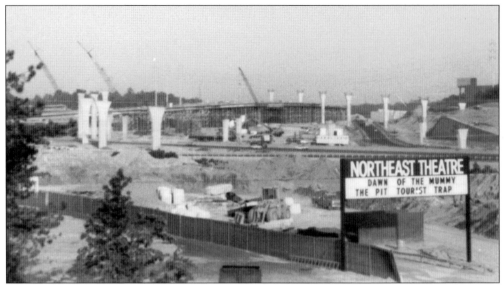

"DeKalb Superlooper" and "Spaghetti Junction" were early nicknames for the $86 million interchange where Interstate 85 intersects with Interstate 285. Its official name is the Tom Moreland Interchange, and the massive transportation project, started in April 1979, was completed on June 9, 1987. Covering 311 acres and with bridge arcs soaring to 90 feet above the ground, the five-level stack design was chosen because it uses about the same amount of space as a traditional cloverleaf interchange. The Northeast Theatre drive-in, one of the last drive-in theaters in Atlanta, was a casualty of the interchange construction. (Courtesy of Merle Evans.)

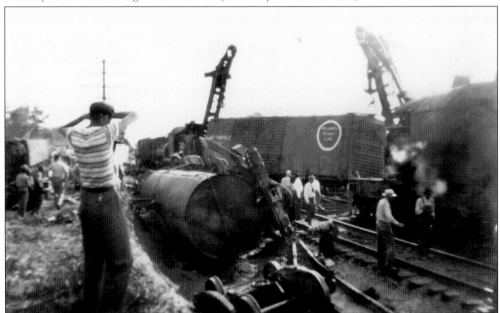

In the late 1940s, residents of Doraville were witnesses to a train derailment just north of the Pelfrey Feed and Grocery store near Winters Chapel Road. No one was hurt, but the wreck caused a major disruption in train service for three days while the derailed cars were removed by crane. The derailed cars were just boxcars; no paying passengers were aboard the train at the time of the wreck. (Courtesy of Marvin Lyle.)

Three

HOW GREAT THOU ART

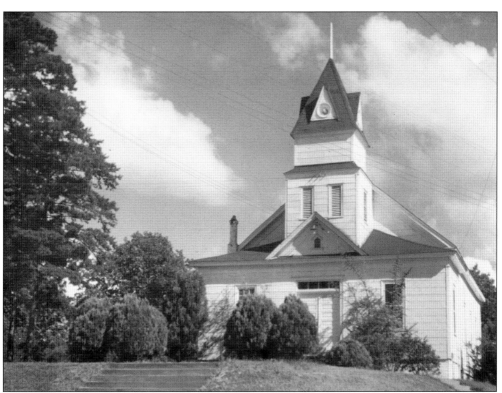

On August 11, 1836, a small group gathered at the home of Samuel McElroy Sr. and created the Prosperity Associate Reformed Presbyterian Church. The church was initially located on Peachtree Road, but moved to the corner of Central Avenue and Church Street in Doraville (pictured) in 1871. A new sanctuary was built on the same location in 1967. This latter structure was sold to the Salvation Army 32 years later, and the last worship services on "the highest hill in DeKalb County" were held on February 20, 2000. (Courtesy of Doraville Library.)

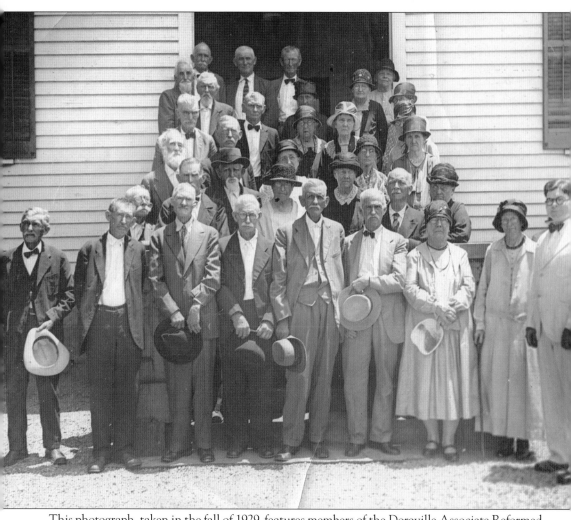

This photograph, taken in the fall of 1929, features members of the Doraville Associate Reformed Presbyterian Church who were 70 years of age and older; they had just been honored by a special service at the church. Pictured here are, from left to right, (first row) R.F. Bolton, W.A. Wiley Jr., J.W. Creel, W.E. Hughes, P.H. Grant, R.S. Chesnut, ? Milford, ? Hughes, and Rev. W.M. Boyce (the only person pictured who was younger than 70); (second row) J.C. McElroy, D.J. Langley, J.M. Morris, Sarah Morris, ? Pounds, Sidney Smith, and ? Smith; (third row) T.T. Stewart, R.W. McElroy, ? Henderson, ? Cowan, Margaret McCurdy, ? Meadows, Sara Howard, and ? Maloney; (fourth row) J.D. McCurdy, T.P. Grant, J.W. Warren, ? McDonald, ? Patterson, and Mattie Brown; (fifth row) M.P. Mills (94), W.A. Chesnut, J.J. Maloney, and ? Bowen. (Courtesy of Harriet Leslie.)

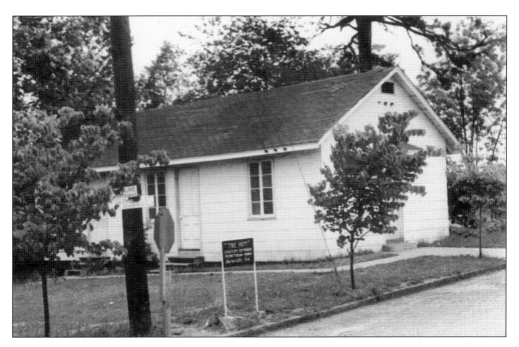

In the spring of 1950, the land adjoining the Doraville A.R. Presbyterian Church at Central Avenue and Church Street, known as the Leslie property, was purchased for $7,500. A small structure, built on the property at a cost of $125, was nicknamed "The Hut." The auxiliary building was a popular gathering spot for the church's Young People's Christian Union (YPCU), Bible classes, and for annual congregational Thanksgiving dinners. (Both courtesy of Doraville Library.)

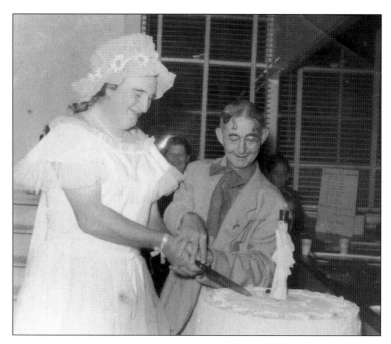

Before the advent of television, Doraville residents created their own entertainment in simple and amusing ways such as the popular "womanless wedding," pictured at left at the Doraville Associate Reformed Presbyterian (ARP) Church. Groom Clyde Spires (right) helps "bride" Harold West cut the wedding cake. (Courtesy of William Spires.)

Teen members of the Young People's Christian Union (YPCU) often held social gatherings and special events, such as the *Toonerville Trolley* play, to raise money. Funds raised at YPCU events paid for church field trips to special out-of-state youth classes and Presbyterian retreats. (Courtesy of William Spires.)

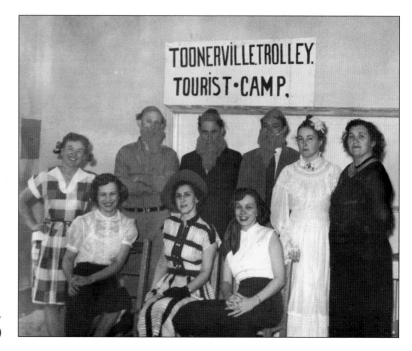

The well at Central Avenue and Church Street was shared by Doraville A.R. Presbyterian Church and the old Doraville School next door because neither property had indoor plumbing. People used two nearby outhouses. Longtime residents remember that the men's outhouse was traditionally turned over by pranksters on Halloween. The deep well, now boarded up, is a truly nostalgic link to Doraville's past—a revered landmark—and efforts to fill it in have always met with opposition. (Photograph by Bob Kelley.)

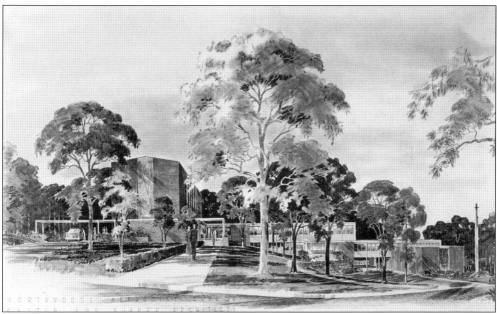

Northwoods United Methodist Church was designed by Ernest Mastin, the architect for the original homes in the Northwoods neighborhood. The church held inaugural services on March 6, 1955, in the Doraville Community Center, with Rev. Richard Baker as its first pastor. That year, J.A. Jones Construction Company donated five lots of land for a permanent church site, bordered by Fairlane and Raymond Drives in Northwoods, as a memorial to the Jones family, prominent Methodist laymen. This is Mastin's rendering of the new church; construction was completed in 1958. (Courtesy of Ernest Mastin.)

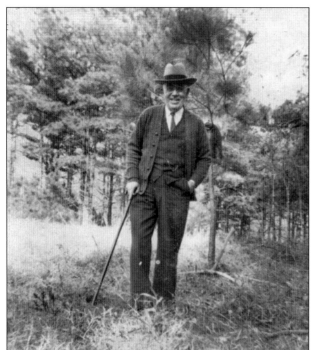

In this March 1950 photograph, Dr. A. Scott Patterson walks the lot for the proposed Doraville First Baptist Church sanctuary on New Peachtree Road. Patterson, the church's first pastor, had previously done foreign mission work in Africa and moved to Norcross with his family in 1948. Taking notice of the commercial and residential growth in Doraville, he approached other members of the Norcross Baptist Church for help in developing a congregation in Doraville. (Courtesy of John Maloney.)

The Doraville First Baptist Church held its organizational meeting in the L.G. Humphrey home on October 14, 1949, with Dr. Scott Patterson presiding. Regular Sunday school and church services were held in the Doraville school building until the church could be erected. The church property, purchased from Dr. John Ebenezer ("Eb") Flowers for $6,000, is on New Peachtree Road across from the MARTA station complex; services were first held in the church on May 6, 1951. (Photograph by Bob Kelley.)

A Doraville Baptist Church primary Bible school group is pictured at right in 1966. Primary Bible school and vacation Bible school were—and still are—eagerly anticipated each year by Baptist youth. Teachers for this particular group included Lynn Wilbanks, Lynn Pritchard, and Dot Whaley. (Courtesy of John Maloney.)

John Maloney uses one of his vintage John Deere tractors to pull a trailer full of young members of Doraville First Baptist Church. In the 1950s and 1960s, long before the advent of cellphones and video games, youth activities often included carnivals, costume parties, choir concerts, hayrides, dances, and field trips. (Courtesy of John Maloney.)

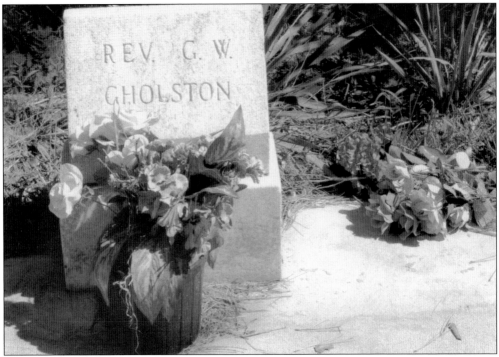

The Greater Mount Carmel African Methodist Episcopal (AME) Church was founded in the late 1870s by Rev. George Washington Gholston. Meetings were first held at the Gholston home, near the present-day location of the Embry Hills area on Chamblee-Tucker Road, then moved to the Odd Fellows Lodge Hall on Peachtree Road, across from Galloway Hardware. When the church was relocated to a storefront building on New Peachtree Road in 1883, the congregation started the first school for black children in the area. (Photograph by Bob Kelley.)

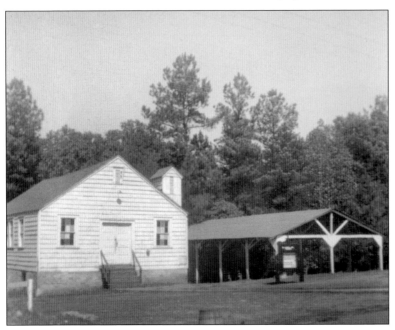

The Greater Mount Carmel AME Church congregation met in a number of buildings over the years, including this one that was located on land that would later contain the General Motors plant. It was moved to Carver Circle, where the current church building was constructed in 1959. (Courtesy of Doraville Library.)

In 1888, land was obtained for a cemetery for the Greater Mount Carmel African Methodist Episcopal (AME) Church on New Peachtree Road near Winters Chapel. In 1912, the church built its first sanctuary next to the cemetery using timber cut on the George W. Gholston property. The church then moved to property that was later occupied by the General Motors plant. Construction of the plant forced the congregation to move to its current location (pictured at right) on Carver Circle. (Photograph by Bob Kelley.)

Zion Full Gospel World Ministries Church, categorized as Baptist, was established in 1877 in Chamblee, Georgia. It is currently located in Doraville at 4091 Carver Drive, across from the Greater Mount Carmel AME Church. Both congregations have worked tirelessly for more than a century toward the betterment of the Carver community and surrounding area. (Photograph by Bob Kelley.)

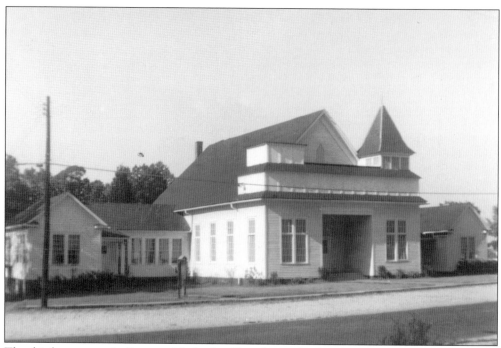

The third sanctuary for Prospect Methodist Church was this building, finished in July 1885. The church's cemetery was located where the Peachtree Indian and Shallow Ford Trails created the early city boundaries between Chamblee and Doraville. This building served the congregation until the mid-1960s, when the church changed its name to Chamblee First United Methodist and moved to Chamblee Dunwoody Road. The building is currently occupied by Biggar Antiques (below). (Above, courtesy of Doraville Library; below, photograph by Bob Kelley.)

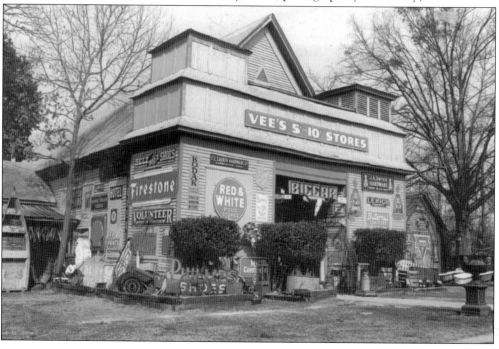

Four

PIONEER STOCK PRODUCES VIBRANT CITIZENS

Archie White was the love of Laura Chesnut's life, and the young married couple had plans to start a family. Archie loved to hunt and, sadly, around 1945, a duck-hunting trip cost him his life. After shooting a duck, he waded into a lake near the DeKalb Water Works to retrieve it. Stepping into a deep hole, his waders quickly filled with water, weighing him down and causing him to drown. Laura was later remarried to a gentleman named "Mac" McDougal. (Courtesy of Tommy Galloway.)

Dura Elizabeth Munday, pictured in 1922, looks every inch a stylish young woman of the Jazz Age. Born on March 19, 1894, she married Hodge W. Norman in 1912, but, unfortunately, he died in 1919 at only 33 years of age. Dura was one of six children born to John W. and Alice Munday, who lived on Church Street in Doraville. Her siblings were Clifford, Ruth, Ella, Margaret, and Floyd Munday. (Courtesy of Connie Johnston.)

The Wilson family gathered for this photograph in the early 1900s. The Wilsons married into the McElroy, Leslie, and Eidson families; all were pioneer Doraville settlers. Robert C. Wilson and his wife, Henrietta, had 10 children and lived on their farm in the Tilly Mill and Winters Chapel Road area. (Courtesy of Harriet Wilson.)

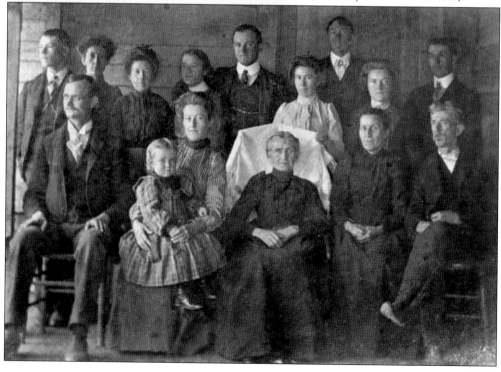

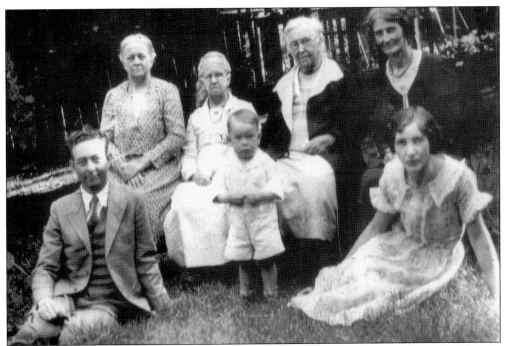

The Spires family was a prominent part of the Doraville community for many years. Four generations are pictured above: in the first row are toddler William "Bill" Spires (center); his father, Clyde (left); and his mother, Linda. In the second row are, from left to right, Daisy Spires (Clyde's mother), Gussie Sullivan (Daisy's mother), Viola Hollingsworth (Linda's mother), and Nancy Weldon Cowan (Viola's mother). (Courtesy of Tommy Galloway.)

Ella Elizabeth Tilly, pictured in 1899 at age 14, was a member of the prominent Tilly family, which ran a cotton gin and corn mill north of Doraville near Flowers Road. (Courtesy of Tommy Galloway.)

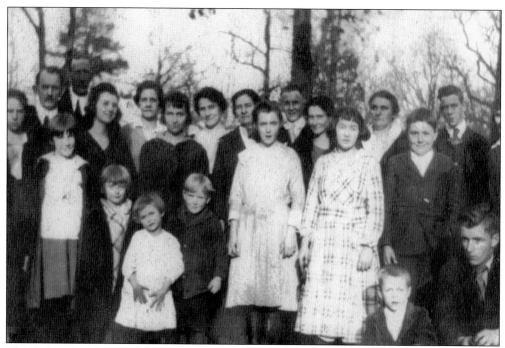

The Cowan family, pictured at a family gathering, ran a gristmill near the Doraville train depot. The gristmill was operated by Oscar Cowan, who had two daughters (Helen and Mildred) and two sons (Nesbit and Porter) with his wife, Nevonia. The Cowan family home was located at the intersection of New Peachtree and McElroy Roads, across from the present-day location of BP. Retired postal clerk William "Bill" Spires' grandmother Viola Hollingsworth was originally a Cowan. (Courtesy of Tommy Galloway.)

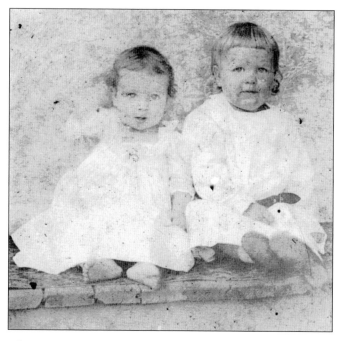

John Wilbert Chesnut, who was born in 1886 and died in 1947, had three children: Sarah, James (both pictured), and Geneva. The Chesnut family descended from David Chesnut II, who was born in Chester County, South Carolina, in 1785 and moved his family to Newton County, Georgia, starting the Hopewell AR Presbyterian Church there before he died in 1837. His grandson, David Alexander Chesnut—John Wilbert's father—was born in Hopewell on August 17, 1840, and is credited with moving the family to Doraville, where he died on December 7, 1914. (Courtesy of Tommy Galloway.)

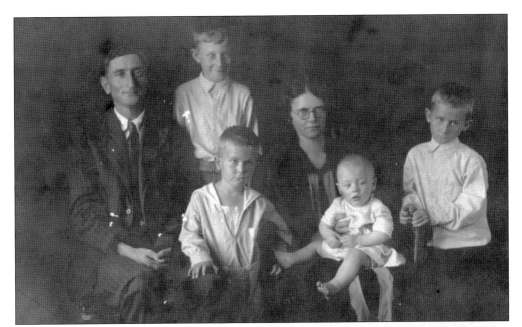

John Stephen Creel married Teru Stewart in the early 20th century, and they lived in a five-room home on Stewart Road that was completed on March 15, 1920, for a cost of $300. The home was a gift from her father, Thomas Turner Stewart. The couple is pictured above with their children Stewart, Ellis, Boyce, and John. Teru taught school when not working on the family farm, where they raised corn, watermelon, cotton, beans, field peas, peanuts, and cantaloupe. According to John Creel, the farm once produced a 69-pound watermelon that was sold to neighbor Charlie Adams for $1! (Courtesy of Mary Shue.)

The image at right shows Dura Munday Norman and her second husband, James Moseley Johnston, on the day of their wedding in 1923. The couple remained happily married until his death on August 24, 1949, at the age of 56. Dura married once more before passing away in 1979 at age 85. (Courtesy of Connie Johnston.)

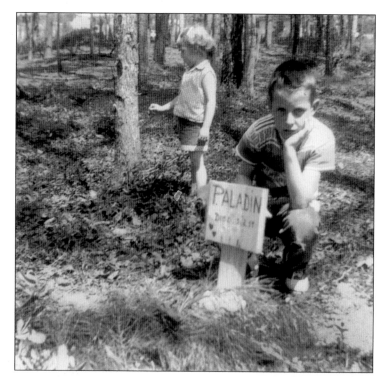

Longtime Northwoods resident John Maloney mourns the loss of his beagle, Paladin, in this early 1960s photograph. His sister, Frankie, is in the background. The pet was named after the main character in a popular Western television show, *Have Gun—Will Travel*. (Courtesy of John Maloney.)

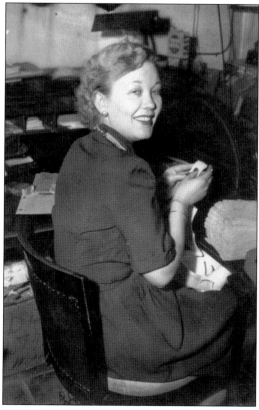

Corinne Sims Lang is pictured at work at Kay Jewelers in Atlanta. She was active in Northwoods beautification efforts and maintained one of the nicest yards in the neighborhood. She and her husband, Lamar, had four children: Coni, Bobby, Ricky, and Carol Lang. (Courtesy of Bobby Lang.)

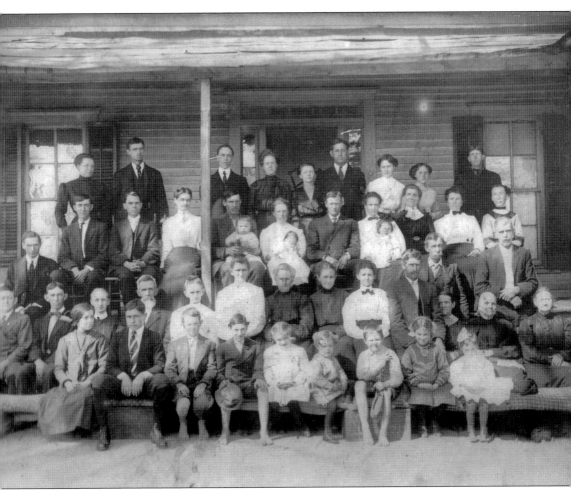

Associate Reformed Presbyterian Church members gather at the home of John Calvin McElroy in 1912. Pictured here are, from left to right, (first row) Marie Roberts, J. Hunter Leslie, Leslie Brown, Leland Ellis, Margaret Roberts, Everett Cox, Fred Brown, Mackey Ellis, and Rebecca Kerr; (second row) Alton Flowers, Todd McElroy, Mead Hunter, John Hunter, Becker Hunter, Carrie Hunter, Frances Elizabeth Hunter Leslie, Becky Leslie McElroy, Margaret Leslie Carmichael Flowers, Joseph Thomas Leslie, Esther Young Leslie, Hattie Sparks, Jane McCurdy, John Calvin McElroy, and David McCurdy; (third row) John Carmichael, Joe Flowers, Rev. M.T. Ellis, ? Ellis, John Calvin Leslie (holding Joseph Emory Leslie), Maebelle Wilson Leslie (holding Samuel Boyd Leslie), James Walter Brown, Elizabeth Leslie Brown (holding Olive), Julie McCurdy, Mag McCurdy, and Dora Jones; (fourth row) Fannie McElroy Roberts, Charles Roberts, Ralph Flowers, Mary Leslie Cox, Flora McElroy Miller, Ernest Miller, Margaret Leslie, Ann Leslie, and Carlos Jones. (Courtesy of Harriet Leslie.)

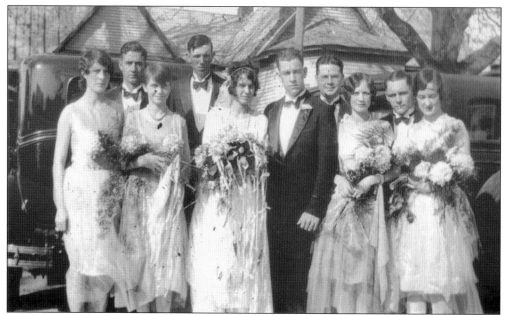

Just two months after disastrous events on Wall Street plunged the country into the Great Depression, the wedding of J.W. (James) Chesnut and Alice Alexander occurred on December 14, 1929. The wedding party included, from left to right, (front row) Teel Dawson, Zaida Alexander, Alice Alexander, James Chesnut, Kathleen Smith, and Laura Chesnut; (back row) Ralph Alexander, Causey Alexander (best man), Oliver Coleman, and Ottis Stapp. (Courtesy of Tommy Galloway.)

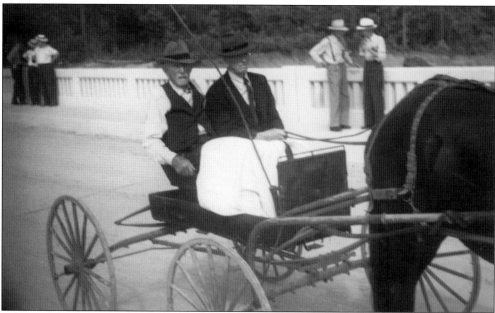

Doraville pioneer descendants Calvin McElroy (left) and Dr. John Ebenezer ("Eb") Flowers parade the old-fashioned way across a newly constructed bridge on New Peachtree Road in the late 1940s. The unnamed bridge, built to allow easier access to the new General Motors plant, crosses what would later become Interstate 285. (Courtesy of William Spires.)

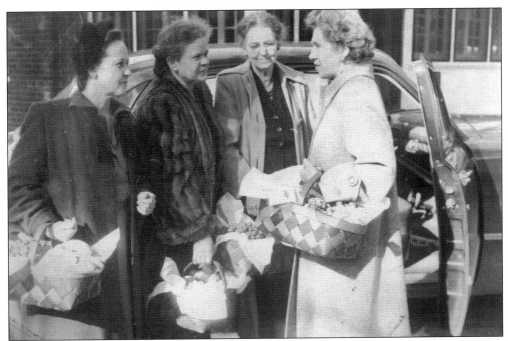

Members of the Doraville Women's Club prepare for a grocery shower in 1951 with baskets of food contributed by Sid Griffin and Bruce Roberts of the Doraville Food Store. The shower was held for the family of Leroy Rogers, of the Doraville Trailer Camp, because he had been ill for some time and was unable to work. The women's club was active for years, raising money for civic projects (including beautification of city parks), helping those in need throughout the Doraville area, and performing smaller deeds such as purchasing venetian blinds for the community health center. (Courtesy of Doraville Library.)

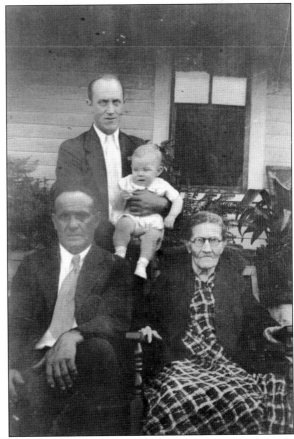

Four generations of the Wilson family are pictured at right. Family matriarch Henrietta Eidson Wilson sits next to her son, Claude; Claude's son, John Claude (standing), is holding his son, Robert. (Courtesy of Harriet Leslie.)

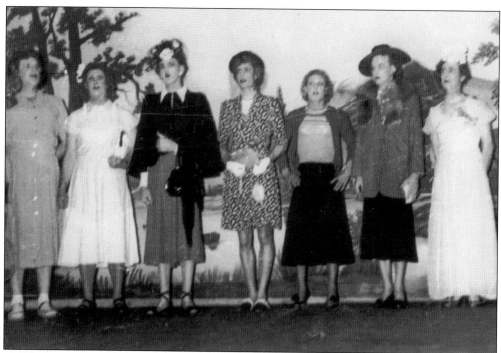

Male Doraville civic leaders often entertained local citizens with fundraiser fashion shows in which they dressed in the latest ladies' fashions. Civic and youth groups in Doraville—including the Jaycees, Kiwanis, Booster Club, 4-H clubs, Boy and Girl Scouts, and others—were continuously raising money to beautify the city and help residents in need. Below, John Creel, second from right, prepares to go rabbit hunting with friends. The Creel family was extremely active in civic projects in Doraville over the years. (Both courtesy of William Spires.)

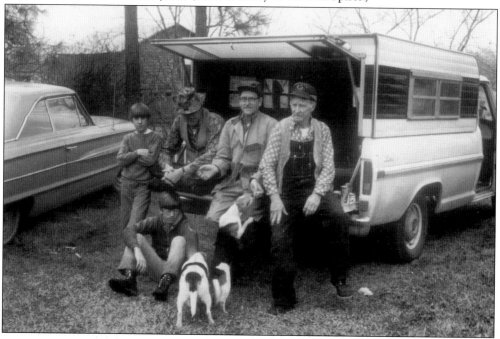

Frank Eugene Maloney, pictured at right with his wife, Ernestine, was a member of a prominent Doraville farming family. He helped deliver milk for the family dairy, which was located on land later occupied by the General Motors plant. He served in both World War II and the Korean War as a mailman first class and won several medals, including the World War II Victory and European-African-Middle East Campaign medals. Discharged in 1951, he returned to Doraville and worked in the Doraville and Brookhaven postal systems in addition to running the family farm. Below is his gas rationing permit issued during World War II. (Both courtesy of John Maloney.)

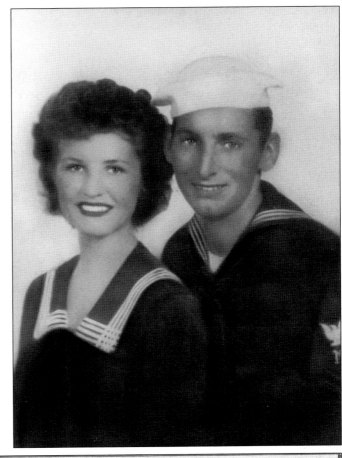

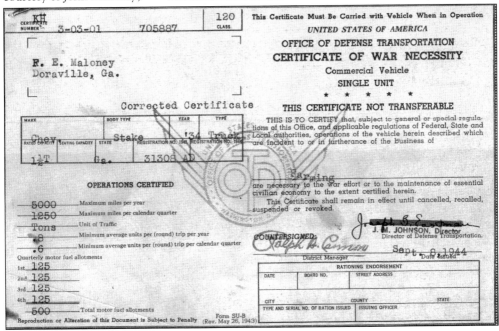

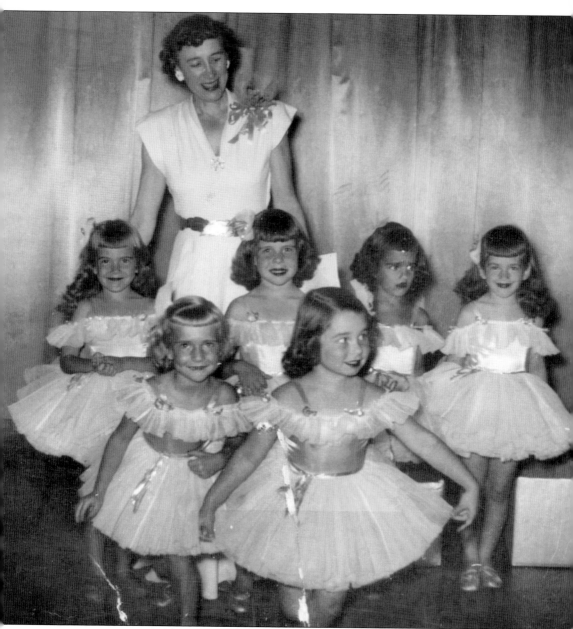

Dressed in curls and crinolines, tiny performers at the Springer Dancing School prepare to dance their way into Doraville's hearts. Dance classes were a staple of many 1950s childhoods, and the youngsters at the Springer school were taught a variety of types of dance. The school was located in the Doraville community building, where this photograph was taken in 1955. (Courtesy of Doraville Library.)

The Munday siblings posed for a family photograph in October 1952. They are, from left to right, Ella, Clifford, Dura, Floyd, Ruth, and Margaret. Clifford was born to John W. Munday and his first wife, Mattie Chesnut. The other five were children of John and his second wife, Alice. The Munday family home, which is now a boardinghouse, is still located in the heart of Doraville at 2702 Church Street. Two sisters married into prominent Doraville families—Ruth into the McElroy family and Clifford into the Leslie family. (Courtesy of Connie Johnston.)

Inez (left) and Todd (center) McElroy are pictured with Flora Miller, Todd's sister. Todd and Flora were the children of longtime Doraville resident "Uncle" Calvin McElroy, who died in 1953 at age 100. Flora attended Erskine College in South Carolina with Susan Blanche Chesnut, graduating in 1905. Her husband, Earn Miller, was killed in an accident by a drunk driver. (Courtesy of Mary Shue.)

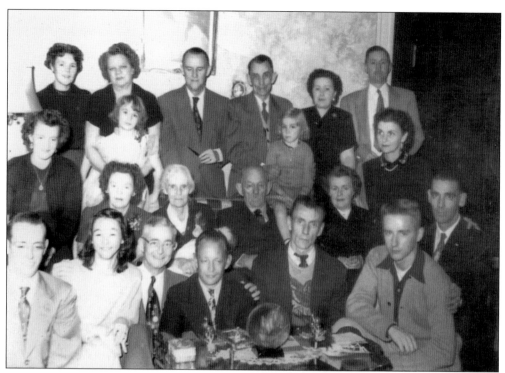

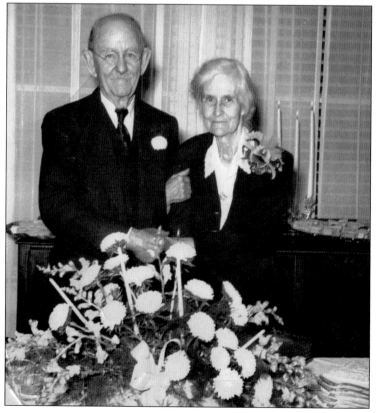

Hollingsworth family members are pictured above at a reunion in the early 1950s. At left, J.W. and Viola Hollingsworth celebrate their 57th wedding anniversary. J.W. and Viola were the grandparents of longtime Doraville postal employee William "Bill" Spires. (Both courtesy of William Spires.)

Yes, it is only a paper moon, sailing over a cardboard sea. Northwoods resident Sadie Roden is pictured at right in 1949, the year she graduated high school, in a novelty photograph taken at the Chattooga County Fair. She and her husband, Harold, have lived in Northwoods for over 50 years in an Ernest Mastin-designed home. As a member of the labor pool, he spent 30 years working in every department at General Motors before retiring at the end of 1979. Over the years, she worked over the years with Southern Railway, Southern Greyhound, and, finally, with the Internal Revenue Service. Below is the couple on their wedding day—January 16, 1952. Their love of ocean cruising culminated in 2012 with a celebration of their 60th anniversary on the *Allure of the Seas*, the largest cruise ship in the world. (Both courtesy of Harold and Sadie Roden.)

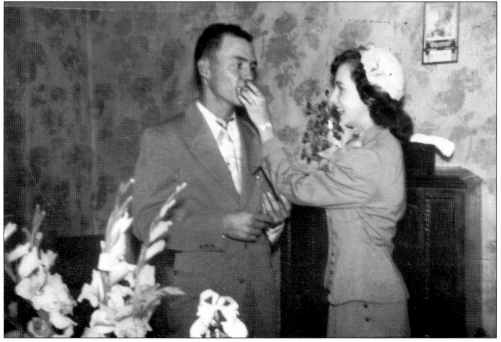

Virginia and George Galloway were the parents of this trio, John Russell (left), George Howard (center), and Thomas Gregory. All three grew up in the Galloway homestead at Tilly Mill and Flowers Road, attended Doraville schools, and went on to attend Erskine College in South Carolina. John is a surgeon at Emory University, George made a career working at Brooks Brothers, and Tommy worked with his parents at Galloway Hardware for many years. (Courtesy of Tommy Galloway.)

Christmas in Doraville guaranteed many youngsters a visit to the downtown Atlanta Rich's department store for the annual lighting of the Christmas tree. For youngsters like Coni and Ricky Lang, the trip also meant a ride on the Pink Pig train and a visit with Santa. Coni and Ricky are pictured having some quality time with the jolly old elf in 1957 or 1958. (Courtesy of Bobby Lang.)

Teru Creel is pictured in later years, when she was lovingly known to all as Granny Creel. Teru, Japanese for "when the sun shines," was the daughter of Thomas and Mary Stewart, a pioneer Doraville family, and married John S. Creel, a local farmer who had a dairy farm and grew cotton, corn, and other produce, using several mules to work their property. As Doraville evolved from a farming community to a more urban area, the city passed an ordinance prohibiting livestock within the city limits. The Creels' son, Ellis, led a crusade to change the ordinance to exclude agricultural animals. The city fathers agreed, and Granny Creel got to keep her mules until the day she died. (Courtesy of Mary Shue.)

Calvin McElroy was the patriarch of the McElroy family, for whom McElroy Road is named. He was rather outspoken yet respected by members of the Doraville community, where everyone referred to him as "Uncle" Calvin until he died in 1953 at age 100. One relative recalled the time when a visiting minister was preaching at the Doraville A.R. Presbyterian Church. The minister had a speech impediment that caused him to run his words together. During the service, Uncle Calvin stood up and loudly prayed, "O Lord, you have sent this man to minister up to us, but we can't understand him. Would you please slow down his speech!" (Courtesy of William Spires.)

For youngsters growing up in the 1950s and 1960s, Easter was always a special time of year that meant a new suit or frilly dress and the requisite photograph holding Easter baskets. Such is the case here with the Maloney siblings John (left), Don (center), Connie, and Frankie (in front). The Maloney family owned a dairy farm on land later occupied by the GM plant. After the plant was built, family members occupied (and still own) several homes on Stewart Road. (Courtesy of John Maloney.)

Key players in Doraville's postal history are captured dining at the Clyde Spires home. The postal employees are, from left to right, Bill Bracewell, Clyde Spires, Boyce Creel, Wesley Presley, and Dr. John Ebenezer ("Eb") Flowers. Dr. Flowers was a third-generation postmaster in the Flowers family. When he retired, Spires became postmaster in 1940, and his son William "Bill" Spires also worked in the postal service. (Courtesy of William Spires.)

Northwoods resident Tom Bearden (left); his wife, Wilma (center); and Carol Lang share a moment. Wilma Bearden taught at Northwoods Elementary School, Tom was an ardent preservationist honored for his efforts to beautify Northwoods, and Carol grew up just a few doors down from the Beardens in Northwoods. (Courtesy of Bobby Lang.)

Julia Stewart Strong, daughter of Thomas Turner Stewart, was the wife of Rev. Edgar Ellis Strong, who came to the Doraville A.R. Presbyterian Church's helm in 1902 and left in 1907 to be minister of a church in Arkansas. Their home was on Stewart Road. The couple had five children, including a set of twins; sadly, one daughter died from scarlet fever and a son drowned in the Tennessee River. (Courtesy of Mary Shue.)

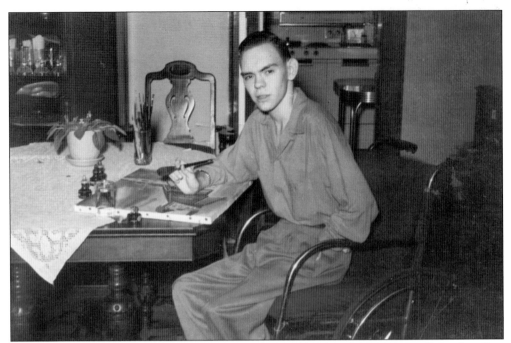

While hemophilia robbed him of the use of his joints and left hand, young Doraville student Roy Epps still managed to learn to paint and excelled in chemistry and mathematics. His paintings included various local churches, such as Doraville First Baptist Church. In the 1950s, handicapped students were not accommodated at local schools so Epps, like many others, was homeschooled; he taught himself Morse code and how to operate a ham radio, among other hobbies. (Courtesy of Doraville Library.)

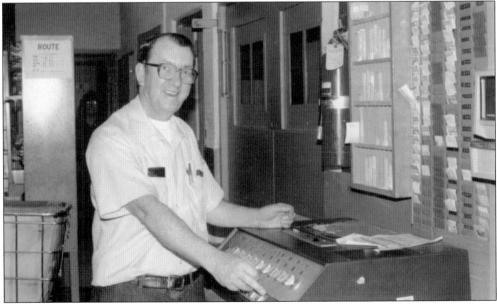

William "Bill" Spires is shown clocking out for the last time at the Doraville Post Office (when it was located on New Peachtree Road). The son of former Doraville postmaster Clyde Spires, Bill worked as a postal clerk for 35 years until his retirement in 1983. (Courtesy of William Spires.)

Five

A SENSE OF COMMUNITY

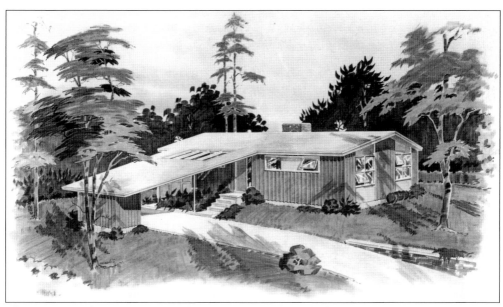

This artist's rendering shows a model home for Northwoods designed by Georgia Tech–trained architects Ernest Mastin and John Summer. Mastin and Summer designed six different houses for the new neighborhood in the mid-1950s. The first ranch houses occupied the southwestern section of the development, and houses such as this one were built in the northeastern section. (Courtesy of Ernest Mastin.)

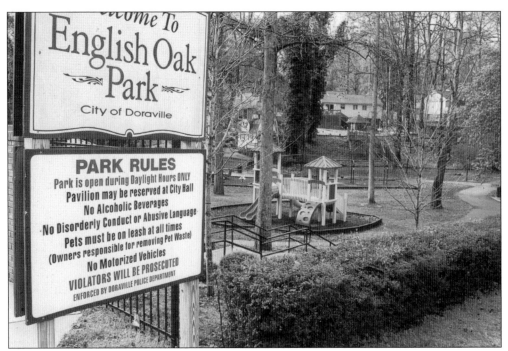

Doraville contains a lot of green space for visitors to play, walk, jog, picnic, and play tennis, softball, football, and soccer, along with many other recreational activities. English Oak Park was recently updated to provide even more outdoor facilities for residents of the Oakcliff neighborhood. Other popular parks throughout the city include Brook and Autumn Parks in Northwoods; Halpern Park, near Moon Manor; Honeysuckle Park; Chicopee Park; and Flowers Park, where the city's swimming pool is located. (Photograph by Bob Kelley.)

Since Doraville was originally a rural farming community, indoor plumbing was a luxury due to the absence of an effective citywide waste disposal system. It was not uncommon to see outhouses in backyards, like this one located on land owned by the Spires family. By the middle of the 20th century, when communities became more widely developed, such outdoor "johns" faded into posterity. (Courtesy of William Spires.)

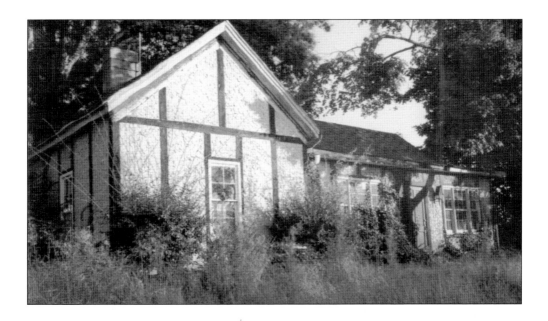

Dr. David G. Miller built this home (above) in the early 1900s on New Peachtree Road across from Park Avenue. Dr. Miller's wife was reportedly so insanely jealous of his female patients that she made him stop practicing medicine. He eventually became the first rural mail carrier in Doraville. The house was demolished in the early 1990s to make way for the Doraville Metropolitan Atlanta Rapid Transit Authority (MARTA) station. Below is a typical Doraville neighborhood, photographed in the 1950s. The location is near the Flowers Road area at the intersection of Clay Drive and Eula Circle. (Both courtesy of Merle Evans.)

Moon Manor homes were built in the same ranch and mid-century style as those in nearby Oakcliff and Northwoods neighborhoods. The large individual lots offered ample opportunity for beautification of the neighborhoods. The nearby 112-home Guilford Village subdivision, constructed by Southern Builders and Engineering Company on 58 acres, was the first one built in Doraville. Moon Manor is located on the southwest border of the tank farms, close to where Tilly Mill Road intersects with Flowers Road. In 1972, wafting fumes from Triangle Refineries drifted toward the pilot light of a furnace in a home in Moon Manor, setting off an enormous fire. During the course of the fire, over 300 homes—many in Moon Manor—had to be evacuated. (Left, photograph by Bob Kelley; below, courtesy of Doraville Library.)

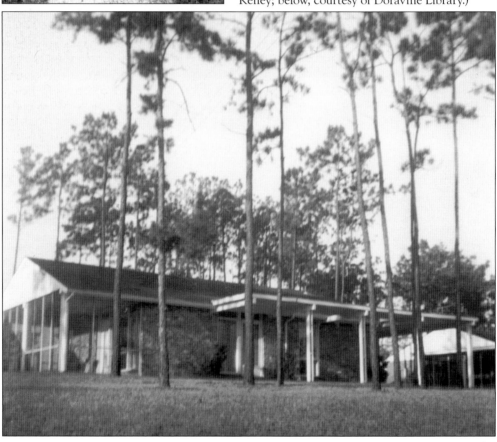

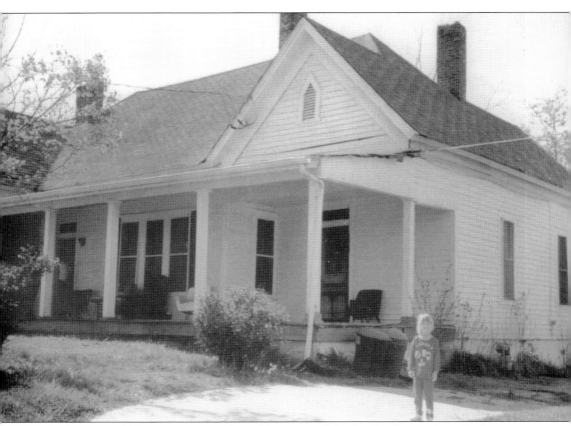

Taylor Reagan, a fifth-generation member of the pioneer Munday family, stands in the driveway of the John W. Munday homestead at 2702 Church Street, near the city center. The Munday home, one of the oldest houses in Doraville, was originally built facing New Peachtree Road, but for some unknown reason was rotated to face Church Street in the 1940s. All of John and Alice Munday's children were born in this house, including Ruth, who grew up and married Weldon McElroy in 1920; Floyd, who married Lois Brooks; Dura, who married Hodge Norman in 1912; and Clifford, who married Young Leslie in 1910. John Munday lived in the home until his death in 1925 at the age of 66. Members of the Munday family owned a thriving cotton gin, located on New Peachtree Road near Park Avenue in Doraville, for many years until the gin burned in 1908. (Courtesy of Connie Johnston.)

Named for African American scientist George Washington Carver, the Carver Hills neighborhood was established in 1949 on 150 acres north of downtown Doraville near Winters Chapel Road and Peachtree Industrial Boulevard. Among other conveniences, the new subdivision featured a school, churches, water, lights, and paved streets. In the photograph at left, a Carver resident works on his home. (Courtesy of Doraville Library.)

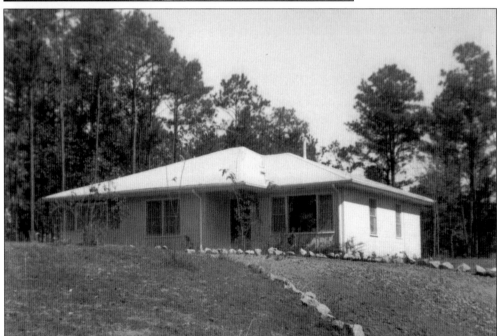

When General Motors purchased nearby land for their new assembly plant—displacing many African American homeowners—as part of the purchase, GM promised to help relocate residents to Carver Hills, which was restricted to black residents. This 1940s image shows a newly completed home in the Carver Hills neighborhood. (Courtesy of Doraville Library.)

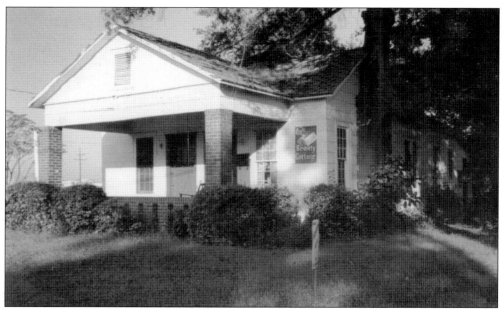

The Joseph E. Munday family owned this home for many years, and it was once known as the oldest residence in Doraville. Built in the 1880s, it was purchased by J.E. Munday for $250 in 1890. The last occupant of the house was Jean's Beauty Cottage. It was demolished in the early 1990s to make room for the Doraville Metropolitan Atlanta Rapid Transit Authority (MARTA) station. (Courtesy of Merle Evans.)

After housing Galloway family members for over a century, this is the Gregory-Galloway house as it appears today. Located on Tilly Mill Road near Flowers Road, the Victorian gingerbread trim may no longer be present, and other slight modifications may have been made over the years, but the house still retains its 19th-century charm. Galloway brothers Tommy and George still live in the home. (Photograph by Bob Kelley.)

Completed on March 15, 1920, at 3667 Stewart Road, the John and Teru Creel home was a wedding present from her father, Thomas Stewart. It cost $300 to construct, featured five rooms, and was built using timber from the Creel farm. The Stewarts, for whom Stewart Road is named, were early Doraville settlers, with Thomas arriving in 1884 from Anderson County, South Carolina. The barn was built in 1947 out of solid oak at a cost of $2,500. Workers were paid 75¢ an hour to build it, and the supervisor was paid $1.50 per hour. The Creel farm, which originally contained 40 acres, included the land on which Cary Reynolds Elementary School and Sequoyah Middle Schools are now located. (Both courtesy of Mary Shue.)

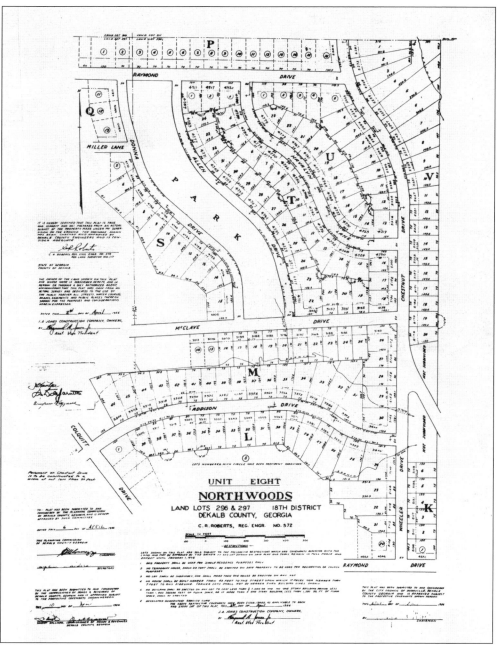

Land lots 296 and 297 are shown on this plat from the 1950s that features a major portion of Northwoods neighborhood. Developer Walter Tally envisioned a community that would attract young families eager to take advantage of DeKalb County's numerous amenities and would provide housing for newly hired employees at the General Motors plant. From 1950 to 1959, 700 new homes were built on 250 acres of land initially bordered by Shallowford Road, Buford Highway, and Addison Drive. Tally's vision included the homes, as well as new schools, churches, a professional building, and a shopping center. The architects designing the community, Ernest Mastin and John Summer, were able to adapt their plans to the area's hilly topography by creating split-level homes that easily sat atop sloping lots. (Courtesy of Ernest Mastin.)

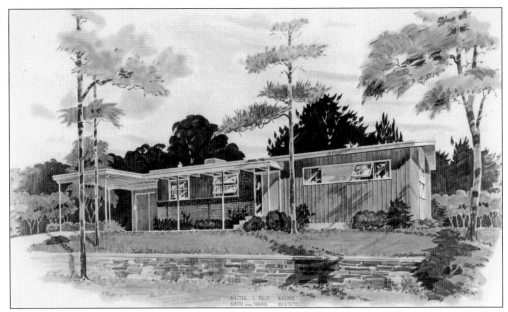

The traditional modern and ranch-style homes built in Northwoods did not feature attics. Builder Walter Tally felt that eliminating attics saved on extra roof bracing, roof joists, cripple studs, boxing the eaves, and flashing. With the new style, buyers did not have to crawl around in a dark attic storage space and could gain 50 percent more closet space and 50 to 75 more square feet of first-floor living area due to not having an attic. (Courtesy of Ernest Mastin.)

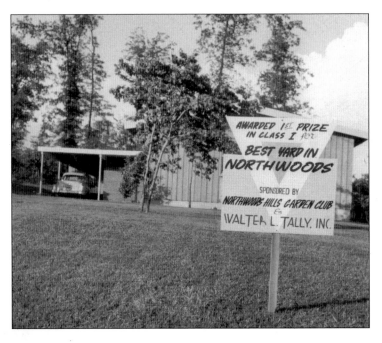

"Best Yard" awards have been given in Northwoods from its inception in the 1950s. The huge, often slightly sloping wooded lots provided a wonderful platform for landscaping and beautification. Over the years, the awards have been sponsored by garden clubs, civic-minded individuals, and neighborhood associations. (Courtesy of Doraville Library.)

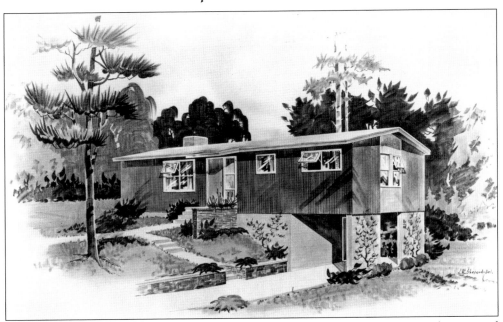

Ernest Mastin and John Summer's architectural style emphasized the importance of nature and the outdoors, so many Northwoods homes boasted patios and outdoor barbecues. Sliding glass doors were modern design elements that connected the home's interior with the outdoors while also providing light and ventilation. Floor-to-ceiling windows also provided a blend of the indoors with the outside environment. Some of the models, with flat roofs and no attics, gave the homes a more modern look—daring features for middle-class residential architecture in the mid-20th-century conservative South. (Courtesy of Ernest Mastin.)

Developer Walter Tally wanted prospective home buyers to choose a lot for their home, then the buyer(s) could meet with Mastin and Summer to customize the home from scratch. The average lot, including the basic house structure, started at around $10,000. Customizing the home was offered on an a la carte basis, and the cost of the home would rise according to the upgrades the buyer(s) chose. Lots ranged in size from 75 to 100 feet in frontage and from 150 feet to 300 feet in depth. (Courtesy of Ernest Mastin.)

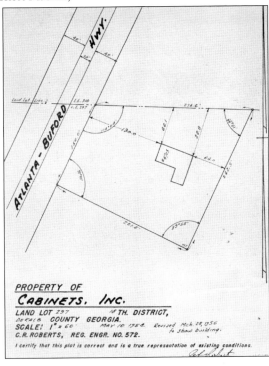

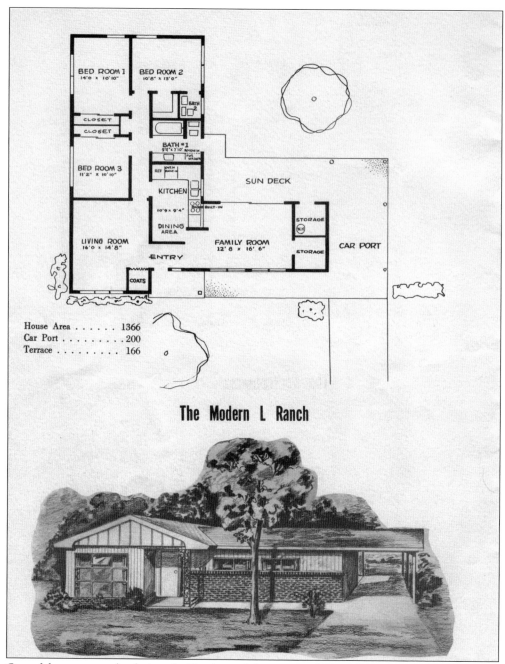

House Area	1366
Car Port	200
Terrace	166

The Modern L Ranch

One of the most popular designs for Northwoods homes was this Modern L ranch, which featured an essential element of the Ernest Mastin/John Summer designs—an open floor space. Kitchens were moved to the front of the house, where they could become a popular area for family gatherings. Northwoods homes boasted modern amenities—like disposals, dishwashers, and wood-burning fireplaces—that were not usually affordable in homes within Northwoods' price range. The popular homes were designed to keep costs low while still being desirable to young home buyers. Being able to meet with the designers to upgrade a home gave buyers a sense of getting a custom home at a bargain price. (Courtesy of Ernest Mastin.)

Six

READING, WRITING, AND ARITHMETIC

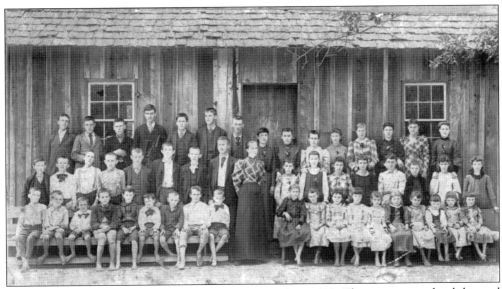

Tilly Mill School students pose for a class photograph in 1893. The two-room school, located at the intersection of Tilly Mill and Peeler Roads, was named for the Tilly family, which owned land and a mill nearby. Area youngsters—some as old as 18—attended the school, and the older students could pose problems when it came to discipline. In the early 1930s, one particular teacher had her hands full with older students who would laugh and run away when she tried to punish them. Harriet Leslie's brother Samuel Boyd Leslie came to the school as principal and quickly brought the problem under control by holding a relay race with the older boys to show that he could outrun them! (Courtesy of Harriet Leslie.)

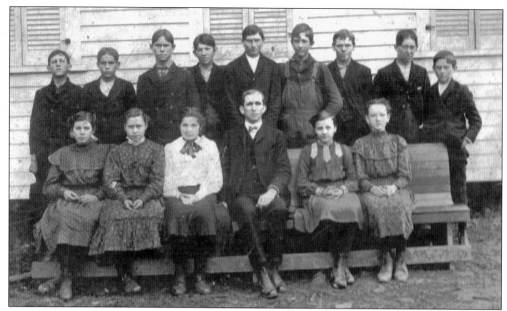

Established shortly after the Civil War by Major John Y. Flowers, Doraville School was founded in 1866 and located in the area that became Flowers Park, near the current city hall. It later moved across the street, next to the Doraville Associate Reformed Presbyterian (ARP) Church at Church and Central Street, and shared the old town well with the church. The school contained six grades taught by two teachers (three if needed). Here, a class poses for a group shot in 1905; Dura Munday is second from right in the first row. (Courtesy of Connie Johnston.)

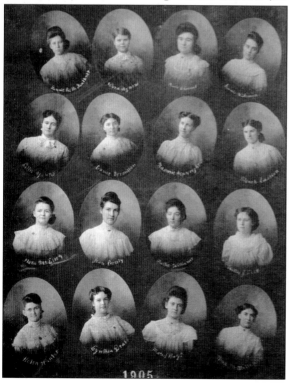

Erskine College was the school of choice for many young Presbyterian men and women raised in the Doraville area. The college, which is affiliated with the Doraville ARP Church, is located in Due West, South Carolina. It played a major role in the education of women, first admitting women in 1894 and becoming officially coeducational in 1899. This early class from 1905 featured Susan Blanche Chesnut (top row, second from right) and Flora McElroy (third row down, at far left), both of whom went on to become prominent Doraville citizens. (Courtesy of Tommy Galloway.)

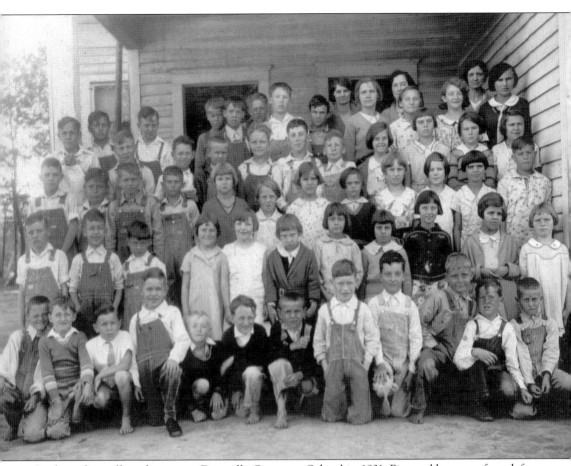

Students from all grades pose at Doraville Grammar School in 1931. Pictured here are, from left to right, (first row), James Wigley, Donald Pounds, W.C. Lancaster Jr., Harold L. (Buddy) Pelfrey, William M. Ross, Elton R. Pounds, Chambers Corbin, George Cheek, Nathan R. Bagwell, Joseph Ford, O'Neil Loudermilk, and Johnny G. Creel; (second row) Frank E. Maloney, Lawrence (Buddy) Wiley, Hunter McElroy, Harriet Leslie, Mary Maloney, Grace Montgomery, Effie Wigley, Lena May Hansard, Dorothy Martin, Margaret McCurdy, and Dorothy Hewatt; (third row) William H. Maloney, Raymond Brown, Robert S. Pounds, Ellis Creel, Mary Frances Eller, Lucille Pittman, Frances McElroy, Freddie Holbrooks, Grace Pelfrey, Winnie Cheek, Eileen Aderhold, and Dorothy Loudermilk; (fourth row) William Brown, Charlie Hansard, Jack Gay, Jack McElroy, John Stewart McElroy, L.D. Corbin, William E. (Junior) Davidson, Robert Bolton, Jady Gay, Lorene Wiley, Alma Hewatt, Annie Sue Cheek, and Ocilla Corbin; (fifth row) H.L. Eller, Robert Wigley, Stewart M. Creel, Raymond Pressley, Edward M. Atwood, Louise Aderhold, Lillie Mae Martin, Mary Ford, and Ida Mae Aderhold. The three teachers in the back row are Evie G. Pelfrey, Laura Chesnut, and Marie Roberts. (Courtesy of Harriet Leslie.)

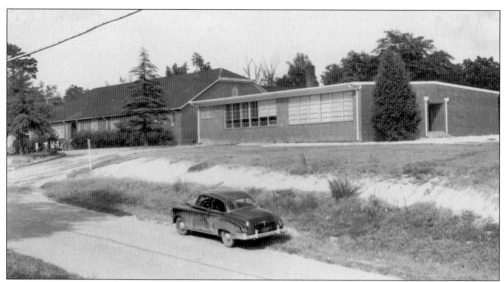

By 1933, the old Doraville School had outgrown its usefulness, and a new school was built at Tilly Mill and Flowers Roads (the present-day site of the bus maintenance facility). This new school featured six classrooms, an auditorium, and a basement. During the Depression, a luncheon program was started at the school; students brought old pots from home in which to cook the food. One of the popular activities at the school was the annual formation of a rhythm band (below) that would perform at PTA meetings and special functions. The music and personal development programs added over the years at the school included art, music, square dancing, tap dancing, music appreciation, radio programs, and arts and crafts. (Above, courtesy of William Spires; below, courtesy of John Maloney.)

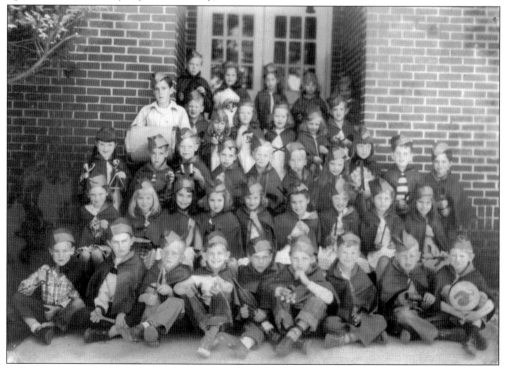

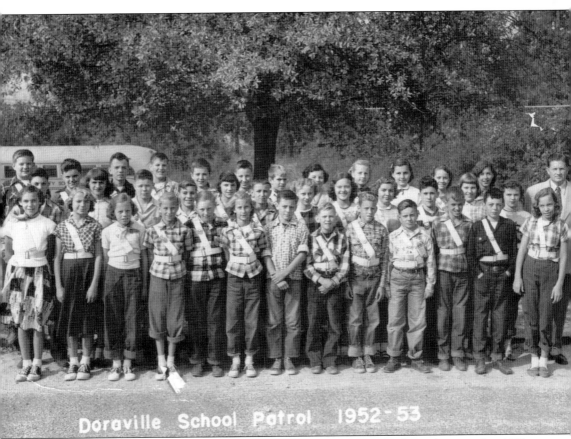

Doraville School Patrol 1952-53

Student safety was emphasized daily at the Doraville School. The school patrol, pictured in 1953, was on duty at street crossings, on school buses, around school driveways, in the school halls, and in other places where needed. Student fire marshals—two from each classroom—were also always on duty, and the children made routine inspections for cleanliness, fire hazards, and safety. Emphasis was placed on teaching the patrol members responsibility and how to do a good job at all times, expecting no reward other than the knowledge that they were helping to provide safety for others. (Courtesy of Doraville Library.)

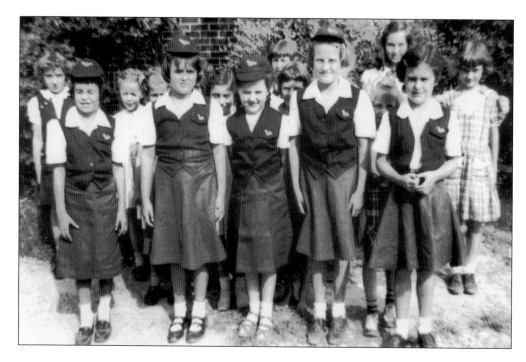

Youth service groups such as the Bluebirds (above) and Boy Scout Troop No. 268 (below) played an important role in the social development of Doraville children. To advance in rank and earn merit badges, the members learned how to make bookshelves and birdhouses, plant shrubs and flowers as part of beautification projects, and utilize outdoor and camping skills. (Both courtesy of John Maloney.)

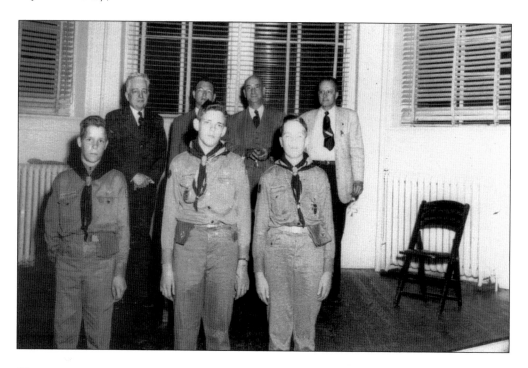

Chamblee and Doraville grade school and high school royalty regally sit atop a float during a Doraville parade in the 1930s. Pictured here are, from left to right, Fred Hensen, Virginia Gregory, Mary Chatter, Joyce Lynch, Polly Tate, and an unidentified girl. (Courtesy of Tommy Galloway.)

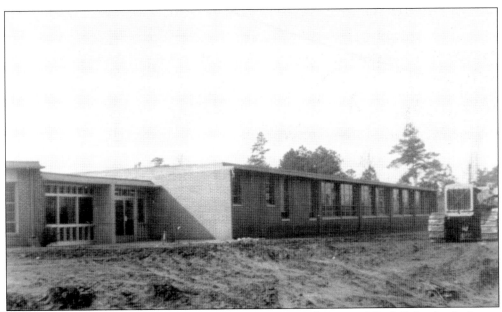

African American students in the Doraville area attended Lynwood Park School, which was constructed in the early 1940s in Brookhaven, near Oglethorpe University. Lynwood Park School was shut down in the mid-1960s after the integration of DeKalb County Schools. In the early 1970s, the county redeveloped the school building into the Lynwood Recreation Center, which is still open. (Courtesy of Doraville Library.)

The purchase of playground equipment for Doraville schools was always a top priority for civic groups, garden clubs, unions, the American Legion, and churches. Playgrounds encouraged children to enjoy being with others; love coming to school; and develop social skills such as sharing and taking turns. Children were encouraged to enjoy free play, as well as organized games like volleyball, baseball, basketball, and softball, to name a few. On rainy days, children would gather in school auditoriums to engage in games and folk dances. (Courtesy of William Spires.)

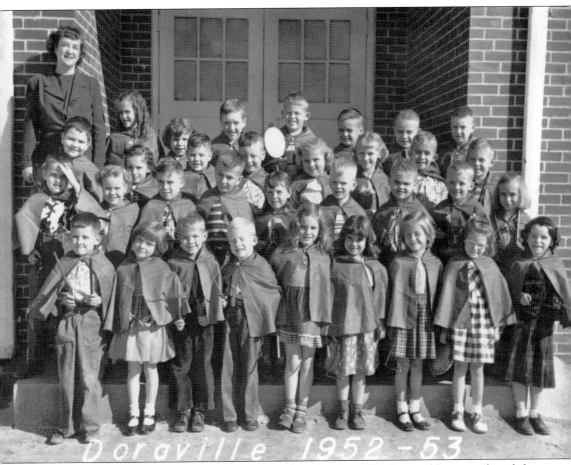

Youngsters pose for a class photograph at Doraville School in 1953. Pictured here are, from left to right, (first row) Jerry Fraser, Patsy Peebles, Joe Albright, Dick Chapman, Patsy Stewart, Betty Ann Callahan, Sheila Mulligan, Martha Christy, and Sara Beek; (second row) Freddie Kirk, Ann Toney, Larry Going, Stoney Stone, Linda Renfroe, Larry Freeman, Joe Johnson, Doug Dempsey, and Jan Baker; (third row) Butch Turner, Martha Setser, Wayne Eskew, Jimmy Dempsey, Linda Lailer, Martha Dodd, Eddie Williamson, and Jimmy Pelfrey; (fourth row) teacher Laura White, Janie Chatham, Jane Dempsey, Jackie Fowler, Marvin Camp, Dickie Askre, Timmy Crippen, and Michael Lord. While this group appears well dressed, the school and children's parents spent time making sure the children were well provided for in terms of clothing, health care, and activities. One system, developed under the direction of the school's welfare committee, collected clothing that had been outgrown and was still in good condition, then laundered it and stored it at the school for donation to children not fortunate enough to have sufficient clothing or shoes; no child went without needed clothing. Any child who could not afford lunch received free lunch, and those unable to pay for school supplies had them furnished by local civic groups and churches. The health of the students was constantly observed, and, if necessary, students were given proper and immediate attention. A nurse in the local Doraville Health Clinic was always on call for Doraville School. (Courtesy of Tommy Galloway.)

The Doraville School students pictured in the 1940s images above and below are celebrating the Easter holiday. The girls above photograph are all decked out in stylish Easter bonnets, while the boys below proudly show off rabbit ears and Easter sacks. (Both courtesy of John Maloney.)

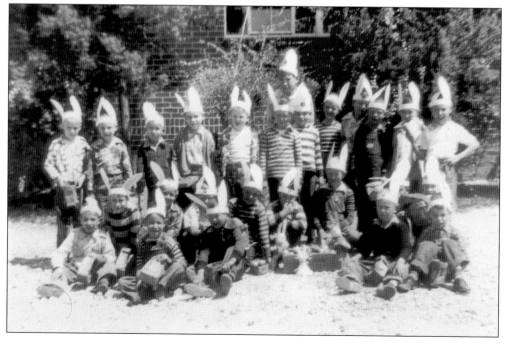

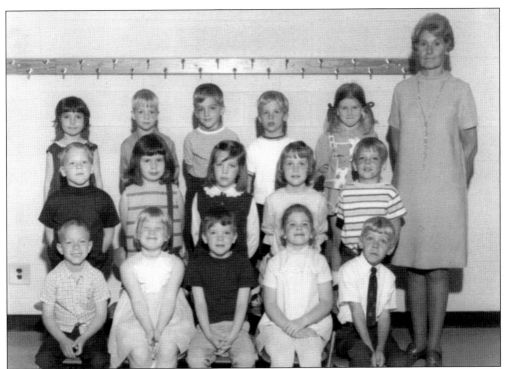

Wilma Bearden is shown with her Northwoods Elementary School class in 1970. Doraville native Maria Alexander is second from left in the second row. Northwoods was the first all-purpose subdivision in Doraville that included schools, churches, and a shopping center all as part of the community. Bearden and her husband, Tom, were Northwoods residents, and he was often honored for his beautification efforts in the neighborhood. (Courtesy of Maria Alexander.)

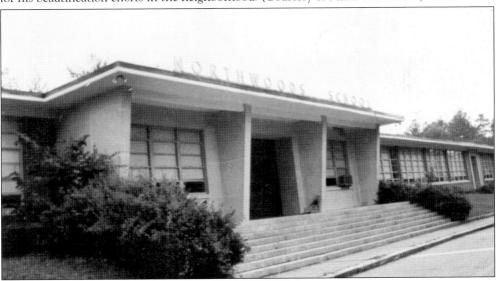

Northwoods Elementary School opened in 1955 as the new subdivision brought more residents into the community. The school closed in 1983 as surrounding communities matured and other schools were built nearby. This building now houses Yeshiva Atlanta, a private high school. (Courtesy of Maria Alexander.)

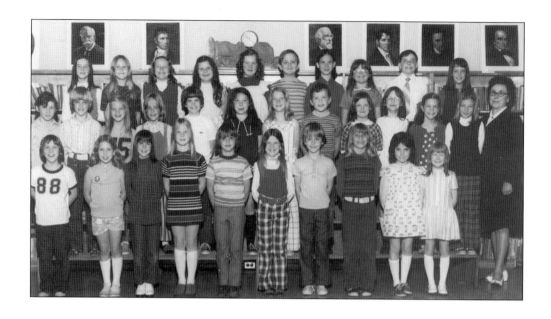

Featured above is a group shot of a 1972–1973 Northwoods Elementary School primary class. Teacher Ruth Middleton is at right, and future Doraville council member Maria Alexander is fourth from left in the back row. Below is the Northwoods Elementary class of 1968. (Both courtesy of Maria Alexander.)

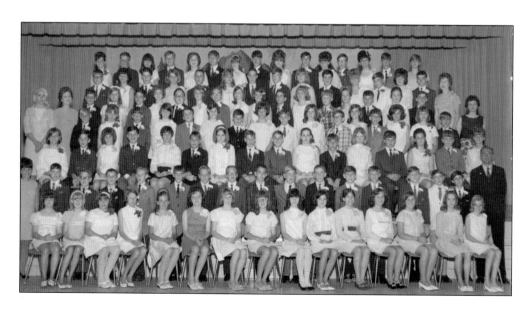

This photograph was taking during recess on the Northwoods Elementary School playground. The playground featured the usual equipment, plus bicycle racks and a flagpole (added in 1955, compliments of the American Legion). Interestingly, in high-use playground areas where grass would not grow, the remedy was to place granite dust on the ground to keep it from becoming too muddy. (Courtesy of Doraville Library.)

Doraville School students are shown making papier-mâché characters in art class. Woodworking, arts and crafts, preparing the auditorium stage for school presentations, and radio programs were a regular part of the school's curriculum. (Courtesy of Doraville Library.)

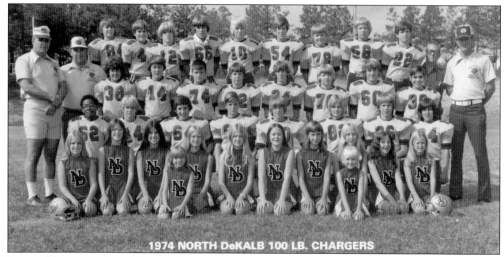

1974 NORTH DeKALB 100 LB. CHARGERS

Pictured here are, from left to right, (first row) cheerleaders Ginger Grant and Kim Strickland; (second row) cheerleaders Pam Hughes, Maria Daunt, Toni Damiano, Jamie Atkinson, Nanci Coker, Susan Kilpatrick, Carrie Staley, Donna Coker, Laurie Lewis, and Connie Bagley. The players are, in no particular order, John Grier (10), Greg Grant (12), Ken Escoe (14), Jeff Rice (22), Steve Segraves (24), Brian Martin (26), Tom Heavern (34), Jim Bradley (36), Chris Derepentigny (38), Greg Strickland (44), Tim Richards (46), Chuck Walker (52), David Adams (54), Tommy Beaube (58), Bob Pugh (60), Sebastian Etchison (62), Bill Maloney (64), Ricky Bowman (66), Stan Rutledge (72), Kim Holman (74), Mike Stiles (76), Chris Thornton (78), Greg Robertson (80), Bobby Greenway (82), Kevin Polston (84), and Mike King (86). Coaches are John Escoe, Bobby Pugh, Doug Ivie, and Bobby Richards. (Courtesy of Vivian Thornton.)

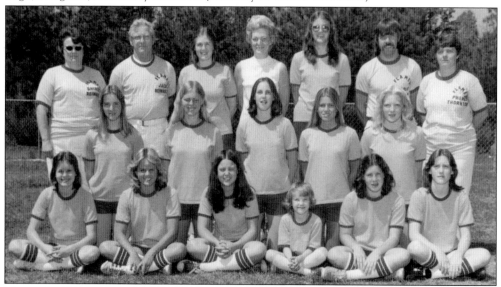

This is the 1976 North DeKalb Flames, a champion softball team from the Doraville area. Pictured here are, from left to right, (first row) Kim Lavender, Darci McClure, Charlene Jackson, mascot Jennifer Lee, Kay Conarro, and Kerri Lee; (second row) Jody Lee, Alicia Thompson, Nancy Davis, Fran Wingate, and Kathy Woodruff; (third row) coach Shirley Reinhold, coach Jack Reinhold, team mother Tracey Thornton, Rusty Woodruff, Sue Moir, coach Charlie Chatham, and coach Pruney Thornton. (Courtesy of Vivian Thornton.)

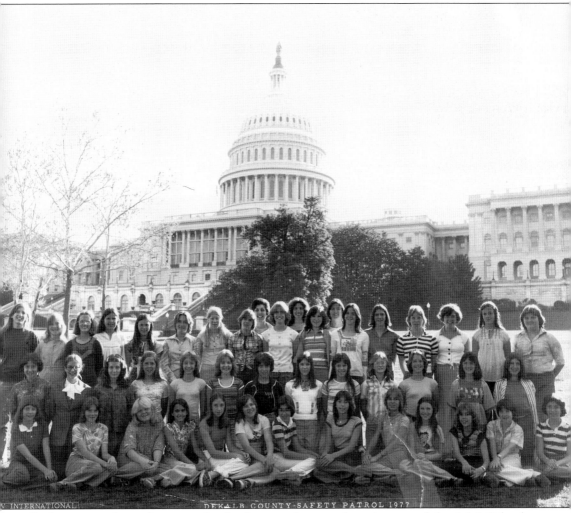

INTERNATIONAL DEKALB COUNTY-SAFETY PATROL 1977

Each year, members of various school safety patrols were selected to attend the AAA School Safety Patrol conference in Washington, DC. Funds for the annual trip were raised by DeKalb County school patrol members conducting various activities, such as selling Krispy Kreme donuts. Maria Alexander is pictured fourth from the left in the back row. The AAA School Safety Patrol program is the largest safety program in the world, with more than 600,000 children participating at 31,000 schools throughout the country. As part of the program, AAA makes available to participating schools the tools required to train patrols and keep them safe, and recognizes their achievements at conferences such as this one. (Courtesy of Maria Alexander.)

Sequoyah Elementary School was built in Northwoods in 1961 on the site of an old cornfield formerly owned by the Creel family. The school was designed by famed Atlanta architect John Portman as one of his earliest design projects. Originally called Northwoods Area Elementary School, the name was changed to Sequoyah Elementary School when a four-classroom addition was built around 1963. After Cary Reynolds, the school's popular principal, died from leukemia in 1963, the name of the school was changed to Cary Reynolds Elementary School—the name it still bears today. (Above, rendering by J.N. Smith; below, photograph by Gabriel Benzur, 1960, Sequoyah Elementary School Collection, John Portman & Associates.)

John Portman also designed Sequoyah Middle School (as it is currently known), and that structure went through a number of name changes and student configurations, too. In early renderings of the school, it was referred to as Cherokee High School, but by the time it was built in 1963, the name had been changed to Sequoyah High School. Various additions were made to the school throughout the 1960s, including a woodworking shop, an electronics classroom, a drafting classroom, an arts room, the science wing, and a gymnasium. It became a junior high school in 1989. The photograph below shows the high school's graduating class of 1982. (Above, photograph by Clyde May, 1968, Sequoyah High School Collection, courtesy of John Portman & Associates; below, courtesy of Maria Alexander.)

Over the years, this school bell summoned thousands of children to class at the Doraville School, which was founded in 1866. As the location of the school changed, the bell was ceremoniously moved to each new school building. It rang for the final time when the last incarnation of the Doraville School, located on Flowers Road near Tilly Mill Road, closed in 1972. Wanting to save the relic to memorialize the school, postmaster Boyce Creel sent a mail truck to rescue the bell, and it was eventually placed in front of Doraville City Hall as a monument. (Photograph by Bob Kelley.)

Seven

GENERAL MOTORS DRIVES GROWTH IN DORAVILLE

The General Motors plant in Doraville opened with great fanfare and a two-day celebration on June 15 and 16, 1947. Atlanta mayor William B. Hartsfield was a featured speaker at the event, and nearly 18,000 people toured the facility to see how automobiles are manufactured. Initially, the primary make of automobiles at the plant was Oldsmobile, but in later years, other automobile lines made there included Chevrolet, Buick, Saturn, and Pontiac, to name a few. (Courtesy of Norfolk Southern.)

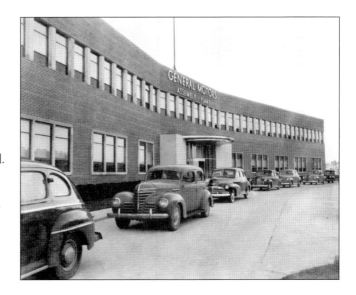

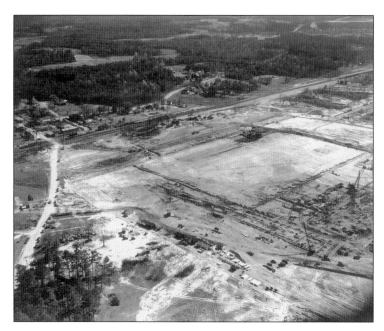

This aerial view of the General Motors' plant construction site provides an idea of the gigantic size of the complex. The original plant covered 17.5 acres, with 897,000 square feet of space devoted to production operations, and the employee count on opening day was 1,250. General Motors' initially invested over $6 million to develop and build the manufacturing facility. (Courtesy of Susan Crawford.)

Doraville was proud to be the "Southern home of General Motors." Local merchants and the Doraville post office hung "welcome" bunting on the plant's opening day in 1947. In anticipation of the grand opening festivities, residents and merchants pitched in to clean up the city by picking up trash, chopping weeds, washing windows, and scrubbing sidewalks to put a sparkle on the town. The civic club, women's club, and local merchants sponsored the cleanup effort. (Courtesy of William Spires.)

General Motors spent $171,667 to buy 408 acres from 50 landowners to build their new manufacturing facility; many of the property owners were African American. As part of the purchase agreement, GM helped relocate these residents to a specially created, 150-acre neighborhood named Carver Hills (in honor of George Washington Carver). Below, a cavernous portion of the plant is shown before the installation of manufacturing equipment. (Both courtesy of Susan Crawford.)

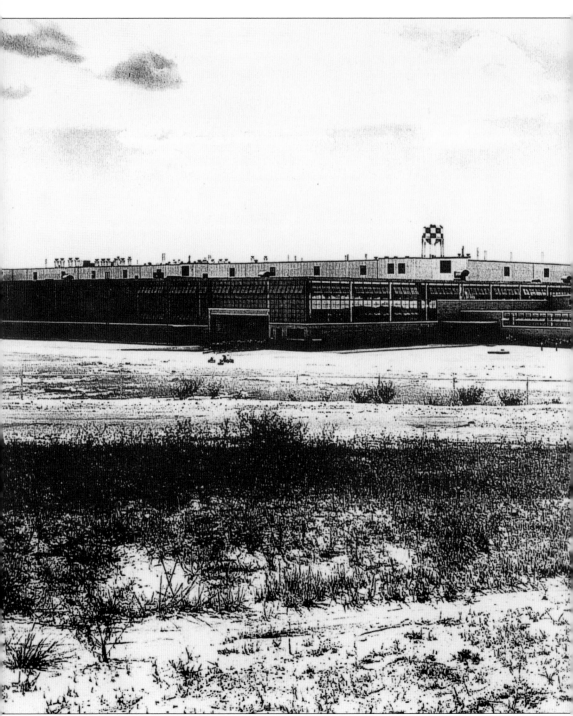

The Doraville General Motors assembly plant was the last of three GM assembly plants built after World War II. The other two plants were in Wilmington, Delaware, and Framingham, Massachusetts. The Doraville factory was considered the most modern in the industry and was built to supply eight Southeastern states with Buick, Oldsmobile, and Pontiac cars. The first Doraville plant manager was W.H. Bolte, who formally opened the plant. It took 12 years for workers to

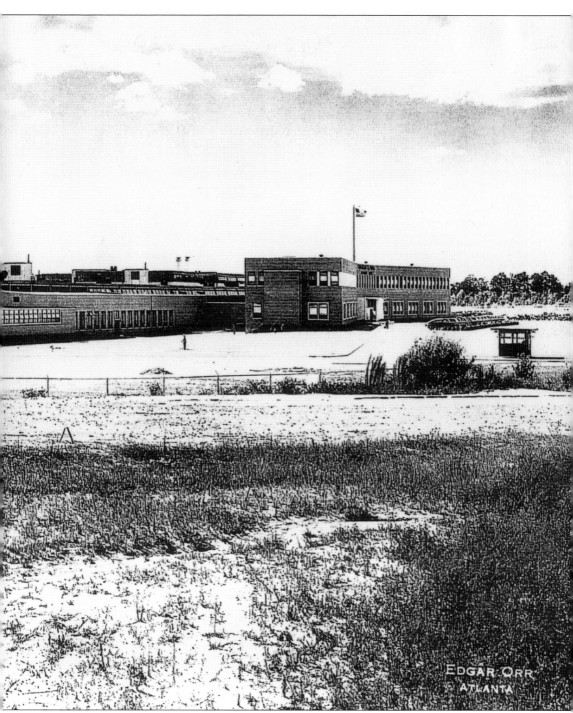

produce the first million cars at the plant, 20 years to reach two million, and 25 years to hit three million. By the time the 2,000,000th vehicle was manufactured at the plant on November 15, 1966, the employee count had grown to over 4,000, and the plant had been expanded to almost 2,000,000 square feet. (Courtesy of Susan Crawford.)

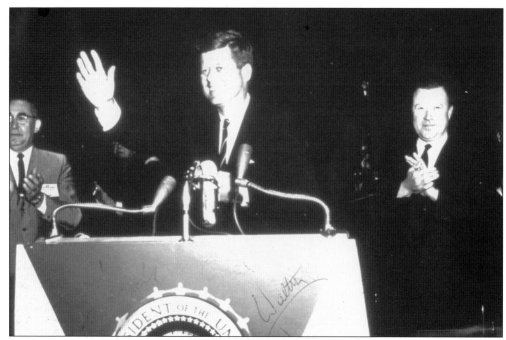

Walter Reuther made the United Auto Workers (UAW) union a major force in the US automobile industry. He is at right above, applauding a speech by Pres. John F. Kennedy at a UAW constitutional convention. The UAW Local 10 in Doraville, once visited by Reuther, played an important role in Doraville's postwar growth through contributions to local charities. One of their most respected leaders, James Herbert ("Herb") Butler, served in various leadership roles after joining the union's organizing committee in 1948. The union hall, located on Buford Highway at Park Avenue for many years, was named in his honor. Below, General Motors and Local 10 leaders cut the ribbon to open a new paint department at the GM plant in the mid-1980s. Pictured below are J.J. Johnson, shop chairman (left); Don Chenoweth, GM plant manager (center); and Jerry Hall, president of the UAW Local 10. (Both courtesy of UAW Local 10.)

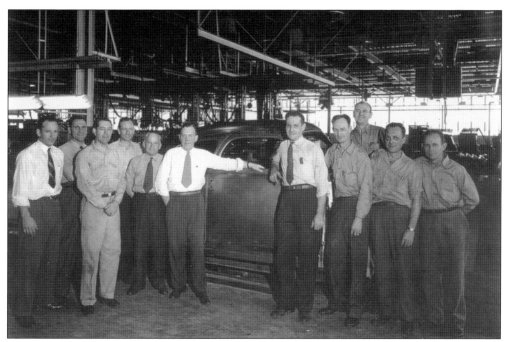

Leaders in the GM body department posed for a group photograph on November 10, 1947. Pictured above are, from left to right, J.J. Michaels, inspection foreman; S. Yacus, foreman; W.L. Landrum, foreman; J.A. Woody, foreman; W.A. Gaff, foreman; A.A. Jacobsen, superintendent; A.L. Budzinski, general foreman; A.L. Hansen, foreman; J.E. Caldwell, foreman; D.D. Norman, foreman; and W.D. Mitchell, foreman. The construction of the GM plant brought many other major improvements to Doraville, including the expansion of Peachtree Industrial Boulevard (below), which was needed to accommodate increased traffic in the area. (Above, courtesy of Susan Crawford; below, courtesy of Norfolk Southern.)

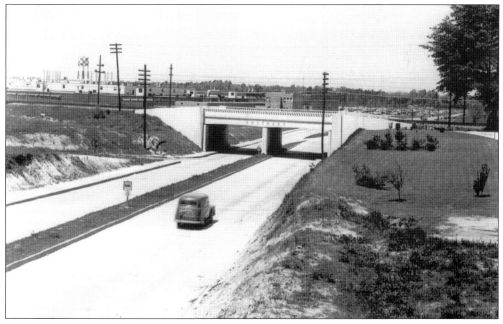

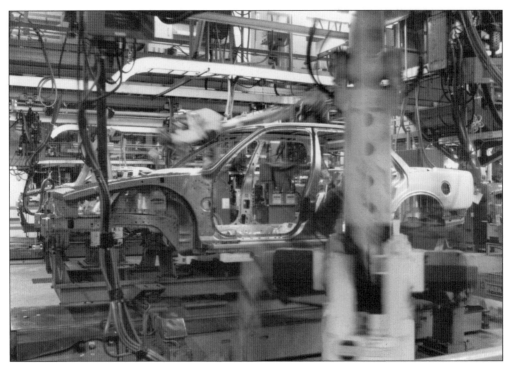

At the Doraville General Motors plant, the motor compartment area of the body shop (above)—aka the "spider" area—was where the individual automobile manufacturing process began with a customer order and Vehicle Identification Number (VIN). Up to 450 robots did the welding in this area. All of the vital pieces of the car, including rear compartments, body sides, the hood, the roof fenders, and liftgates were welded together here. Once the car left the paint shop, it went to the general assembly or accumulator area. By this point it had been stamped, welded, framed, primed, and painted, and it came to the general assembly area for the addition of the items that made the vehicle function. (Both courtesy of Wayne and Patty Barker.)

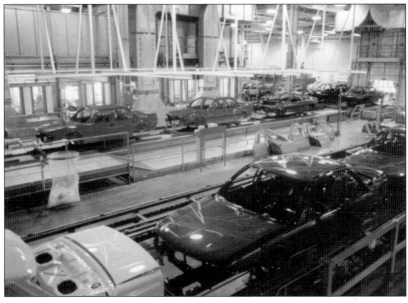

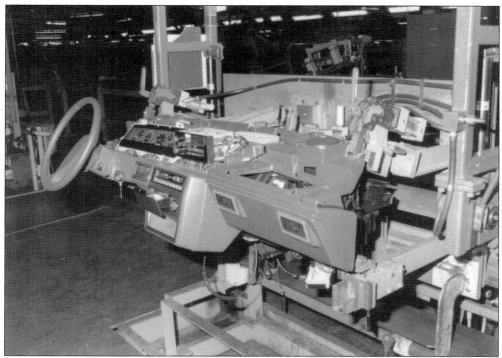

In the trim area at the Doraville GM plant (above), the shiny vehicle shell was transformed into a functional automobile. This is where windshields, instrument panels (called the cockpit), luxury seats, carpet, and headliners (among other items) were attached, seated, connected, and installed. By the time the car made it to the chassis department in general assembly, it was time to "marry" the vehicle body to its chassis and install the engine into the car (below), adding electrical harnesses, drive trains, brake systems, exhaust systems, and tires. Thousands of customer-specified parts, features, and colors united at this point to form two perfectly matched vehicle halves that were then joined together. (Both courtesy of Wayne and Patty Barker.)

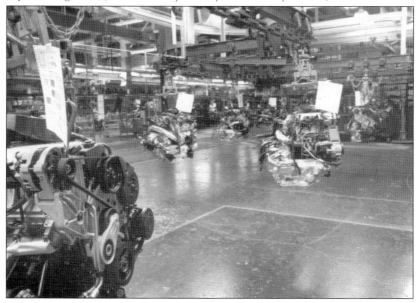

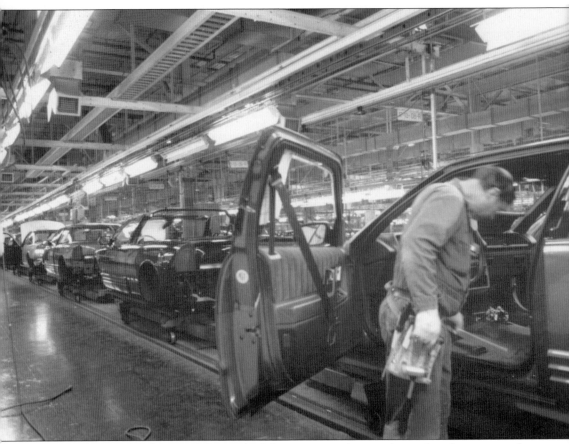

When the completed automobiles reached the inspection line in the quality department, they went through a series of tests and quality checks as they advanced down the final line. At the end of the line, every vehicle went through an additional series of functionality tests. Finally, the cars were run through a squeak and rattle track. The Customer Acceptance Review Evaluation (CARE) was the last quality assurance filter. This evaluation was used to detect any defects in a car's construction. (Courtesy of Wayne and Patty Barker.)

This Chevy Impala was part of a special batch built at the Doraville GM plant in 1973. The 1,000-car run produced the first American-made cars to feature passenger air bags. GM integrated technical designs by Fisher Body into the trendy four-door Impalas but, due to the available technology at the time, the air bags (initially known as front seat air cushion restraint systems) were installed for front-seat passengers only. The back seat retained the usual seat belts. Unfortunately, because of a lack of acceptance from drivers, this version of the Impala failed to gain popularity and played a part in delaying the spread of air bag technology for nearly two decades. According to John Kyros at General Motors Global Media Archive, the Impala pictured above is one of only two surviving cars from the original 1,000 produced at the Doraville plant, and it is estimated to be worth $500,000. (Courtesy of General Motors Corporation.)

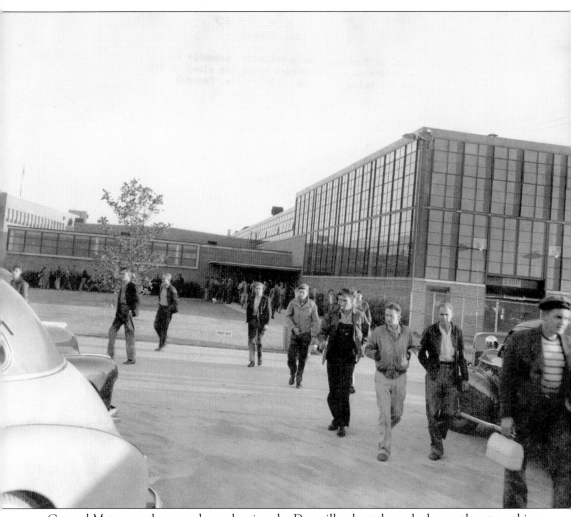

General Motors workers are shown leaving the Doraville plant through the north gate parking lot at shift change. Every employee had to enter and leave the plant at this location. When the plant closed on September 26, 2008, as a cost-cutting measure, it ended a prosperous, 61-year relationship between Doraville and the automobile manufacturing giant. Doraville lost a business partner that had given much to the community, creating jobs for thousands of people and putting many tax dollars into city coffers. The employees of the plant also often lent a charitable hand. In the wake of September 11, 2001, the plant donated $26,584.13, matched by the GM Foundation, and built six vans to donate to the New York City Fire Department. In the 1980s, workers at the plant raised money through donations to put color televisions into patient rooms at the Atlanta VA Medical Center. They hosted Red Cross blood drives, Care and Share Christmas toy collections, and presented annual checks to charities like the Muscular Dystrophy Association, the March of Dimes, Junior Achievement, Children's Healthcare of Atlanta, and many others. As a Doraville corporate neighbor, they were very much appreciated and are sorely missed. (Courtesy of Norfolk Southern.)

Eight

CANDID DORAVILLE THEN AND NOW

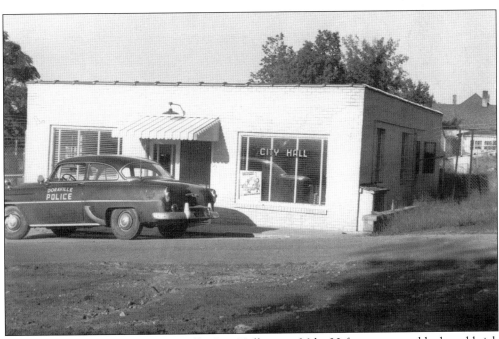

Built in 1949 and 1950, this Doraville City Hall was a 36-by-30-foot concrete block-and-brick building at the corner of Peachtree Road and King Avenue. The structure housed a meeting room, a police station with two jail cells, a main hall, and an office that served as the center of city government until the mid-1960s. At that time, it was torn down and replaced with a maintenance building that eventually became the home of the Paul Murphy Boxing Club. (Courtesy of William Spires.)

This is the current Doraville City Hall, located at 3725 Park Avenue. The building contains office space for the mayor, city clerk, and other city staff; storage areas; and is often used as a polling place for city elections. The building was dedicated on December 11, 1966, amid much fanfare. (Photograph by Bob Kelley.)

Linton Broome, third from left, is sworn in as mayor of Doraville in 1966. During his term in office, the city hall and recreation center buildings were constructed and Buford Highway was enlarged to four lanes. (Courtesy of Linton Broome.)

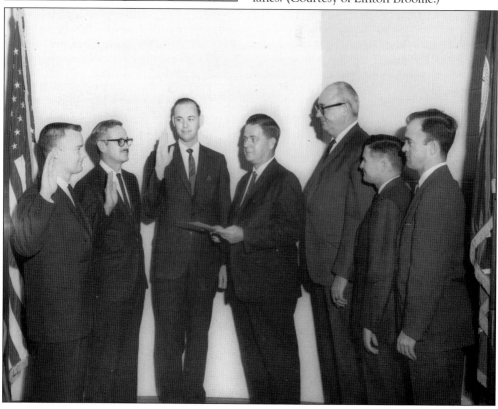

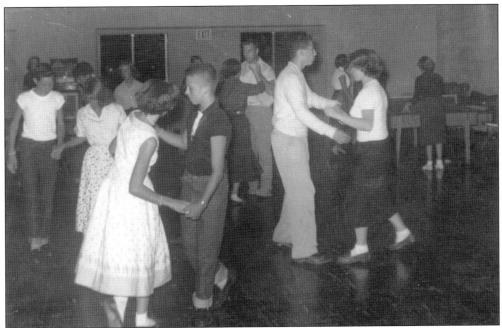

The Braves Cave, named for the Sequoyah High School football team, was a popular hangout for Sequoyah students in the 1960s and 1970s. The facility, which was owned by the city, was operated by Billie Turner, who was beloved by the kids for listening to their problems and offering motherly advice. Activities at the Cave included dancing to jukebox music, playing board games, and just hanging out. A typical date night in Doraville in those days involved dropping by the local McDonald's and heading to the Cave to socialize, dance, and have fun. The Cave's central location—across from the present-day courthouse—made it a convenient stop for neighborhood kids. (Above, courtesy of Doraville Library; below, photograph by Bob Kelley.)

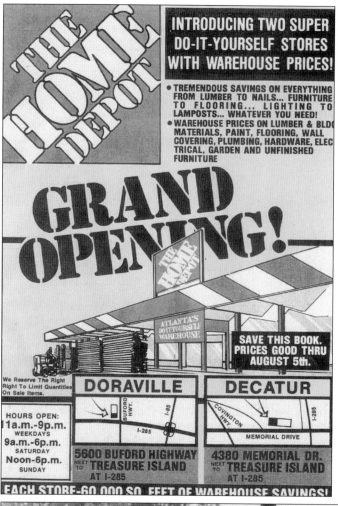

INTRODUCING TWO SUPER DO-IT-YOURSELF STORES WITH WAREHOUSE PRICES!

- TREMENDOUS SAVINGS ON EVERYTHING FROM LUMBER TO NAILS... FURNITURE TO FLOORING... LIGHTING TO LAMPOSTS... WHATEVER YOU NEED!
- WAREHOUSE PRICES ON LUMBER & BLDG MATERIALS, PAINT, FLOORING, WALL COVERING, PLUMBING, HARDWARE, ELECTRICAL, GARDEN AND UNFINISHED FURNITURE

GRAND OPENING!

SAVE THIS BOOK. PRICES GOOD THRU AUGUST 5th.

We Reserve The Right Right To Limit Quantities On Sale Items.

DORAVILLE

DECATUR

HOURS OPEN:
11a.m.-9p.m.
WEEKDAYS
9a.m.-6p.m.
SATURDAY
Noon-6p.m.
SUNDAY

5600 BUFORD HIGHWAY NEXT TO TREASURE ISLAND AT I-285

4380 MEMORIAL DR. NEXT TO TREASURE ISLAND AT I-285

EACH STORE-60,000 SQ. FEET OF WAREHOUSE SAVINGS!

One of the two first Home Depot stores in Georgia opened in Doraville on June 22, 1979. A sister store opened on the same day on Memorial Drive in Decatur. The Doraville store was on Buford Highway, close to the current location of the Buford Highway Farmers Market, but has since relocated to the Tilly Mill/Flowers Road area. This is the first advertisement Home Depot published to promote the new stores. (Courtesy of Home Depot.)

Downtown Doraville in the 1940s was not much more than a wide spot in the road. In this view of the area, just past the building on the left, barely visible, is J.H. "Bud" Maloney's Amoco station, a popular hangout. The entire downtown area disappeared due to the construction of the Metropolitan Atlanta Rapid Transit Authority (MARTA) complex. (Courtesy of Doraville Library.)

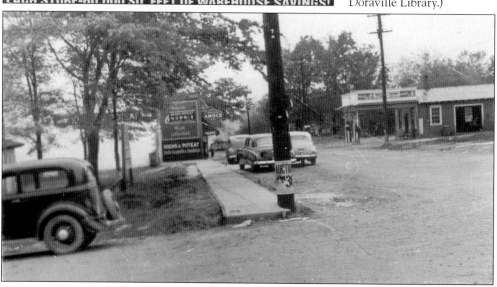

"Doraville, touch of country in the city; Doraville, it ain't much but it's home," sang members of Doraville's homegrown Southern rock band, Atlanta Rhythm Section (ARS) in their hit song, "Doraville." ARS first recorded at the Studio One facility at 3864 Oakcliff Industrial Court in Doraville, which was built by music powerhouses Bill Lowery, Buddy Buie, and J.R. Cobb. Buie, best known for penning hits like "Stormy," "Spooky," and "Traces," managed the ARS and was once Roy Orbison's road manager. Original members of ARS included Rodney Justo, Barry Bailey, Paul Goddard, Dean Daughtry, and Robert Nix, and the group produced 14 studio albums, and performed at the White House while Jimmy Carter was president. (Courtesy of Karin Johnson.)

07253

Doraville
WORDS AND MUSIC BY BUDDY BUIE, ROBERT NIX AND BARRY BAILEY
AS RECORDED BY THE ATLANTA RHYTHM SECTION ON POLYDOR RECORDS

Charles Hansen
EDUCATIONAL SHEET MUSIC & books
1860 Broadway / New York, New York 10023

The Lowery Group

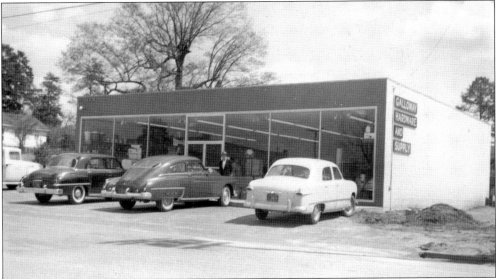

One of the few remnants of old Doraville is this building on New Peachtree Road that formerly housed Galloway Hardware. This photograph shows the store in its heyday in the early 1950s. The building is still there, but the hardware store closed in 2008. (Courtesy of Tommy Galloway.)

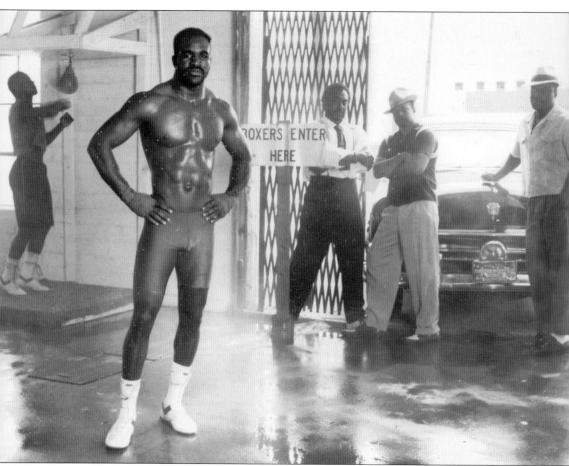

World boxing champ Evander Holyfield grew up in Atlanta and often trained at Doraville's Paul Murphy Boxing Club (then called the Doraville Boxing Club), where he posed for this photograph. The boxing club was founded in 1980 by Doraville boxing commissioner Paul Murphy; the club first used space in the Doraville Community Center before moving to the old Doraville maintenance building on King Avenue. Over the years, it has become one of the major boxing facilities in North Georgia, producing Golden Gloves, Junior Olympics, and North American Boxing Federation champions. Boxers from West Africa and the Philippines trained at the Doraville facility and went on to win gold and silver medals in the 1996 Summer Olympics in Atlanta. Boxers from the US Army's 82nd Airborne Division, stationed at Fort Bragg, North Carolina, have also trained at the club. When Paul Murphy died in April 1999, the club was given his name in honor of his many years of service and dedication. (Courtesy of Paul Murphy Boxing Club.)

BABYGRAM

BABY, TELEGRAPH AND **CABLE CO.**
FATHER STORK, PRESIDENT.

WEIGHT 6½ LBS.

DATE 26 1930

TO FRIENDS AND RELATIONS

EVERYWHERE

ARRIVED SAFELY. DAD AND MOTHER VERY HAPPY

GLAD TO SAY MY NAME WILL BE

SIGNED *Dorothy de Jarnette.*

CARE
MR & MRS *E. Y. de Jarnette*

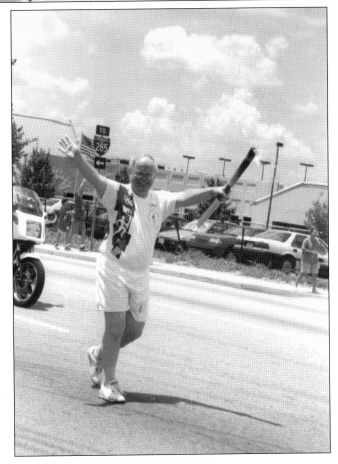

The de Jarnette family intermarried with the Chesnuts, but little else is known about them. This is a birth announcement for Dorothy de Jarnette, who was born in 1930. Dr. John Ebenezer ("Eb") Flowers delivered the majority of babies in Doraville throughout the first half of the 20th century, charging $20 per delivery. (Courtesy of Tommy Galloway.)

The Olympic torch representing the 1996 Summer Olympics in Atlanta passed through Doraville on July 18, 1996, to the cheers of hundreds gathered for the occasion. The torch route traveled north on New Peachtree Road from the Chamblee city limits to Buford Highway. Doraville's location, at the end of the northbound MARTA rail line, helped provide easy access to many of the Olympic venues in downtown Atlanta. (Courtesy of Merle Evans.)

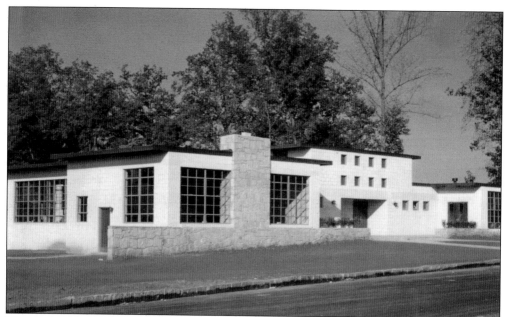

This venerable building facing Park Avenue, across from today's city hall, has served in many capacities. Built in 1953, it was the city's original community center and has housed the Doraville Police Department, Doraville Library, and North DeKalb Health Center. In later years, it served as the Center for Pan Asian Community Services. The structure was built on land donated to the city by Dr. John Ebenezer ("Eb") Flowers and E.S. Grant. (Courtesy of Doraville Library.)

The Doraville City Court facility originally served as a recreation center for local youth and then an arts theater. In 1997, the building, located at 3765 Park Avenue, was remodeled and turned into the city courthouse. Each of the building's three courtrooms seats 126 people, and administrative and probation offices are housed at the location. When the recreation facility was moved in 1989, it was relocated to Forest Fleming Arena in Honeysuckle Park in the Oakcliff neighborhood. (Photograph by Bob Kelley.)

Much of old downtown Doraville disappeared with the construction of the Metropolitan Atlanta Rapid Transit Authority (MARTA) station complex, built in 1992. The station is located on New Peachtree Road, adjoining the railroad tracks between Interstate 285 and Shallowford Road. The 45,000-square-foot facility was built for $20 million and serves as a link from Doraville to downtown Atlanta. (Photograph by Bob Kelley.)

For over 30 years in the last half of the 20th century, the biggest annual event in Doraville was the Shrine Classic and parade sponsored by the Doraville Recreation Department, the Northeast DeKalb Shrine Club, and the YAARAB Shrine. The event raised millions for area hospitals and burn centers, but gradually faded in popularity. The Shrine Classic has been replaced by smaller-scale fundraising activities such as the 5K Fun Run and Tot Trot. The 5K race, pictured below, raises money for Children's Healthcare of Atlanta. (Photograph by Bob Kelley.)

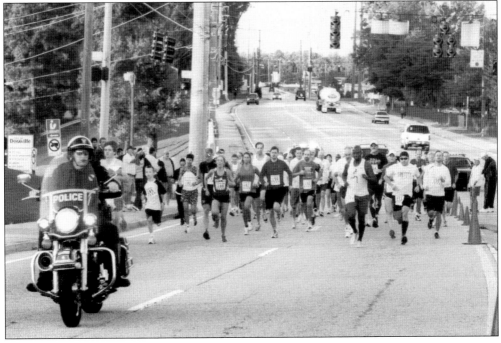

City limits signs leading into Doraville proudly announce that the city is home to astronaut John Casper, who grew up in Doraville and graduated from Chamblee High in 1961. His family lived in the city for 23 years, where his father, Retired Army colonel John Casper, worked for Kodak. After completing his freshman year at Georgia Tech, Casper transferred to the Air Force Academy, became a pilot in 1968, and became an astronaut in June 1985. He piloted the space shuttle *Atlantis* (below) and also served on flights of the space shuttles *Endeavour* and *Columbia*. The four-day *Atlantis* flight in 1990 lasted 106 hours and travelled 1.87 million miles. The Caspers now live in Houston, Texas. (Both courtesy of NASA.)

The current Doraville Library, located on Park Avenue, was built in 1970 and was formally recognized by the city in 1978 as a depository for preservation and display of historic Doraville material. While the 10,000-square foot facility is owned by the city of Doraville, it is open to all residents of DeKalb County. Programs offered at the library include crafts, art, music, international relations, and language classes, to name a few. The library's popular book fair is held several times throughout the year as a fundraiser for the Friends of Doraville Library. (Right, courtesy of Doraville Library; below, photograph by Bob Kelley.)

Proclamation

WHEREAS, the City of Doraville and its environs are rich in historical significance and occupy a place of prominence in the cultural, political, social and economical development of the area; and,

WHEREAS, there are, in and about the area, innumerable articles of historical significance, worthy of preservation for posterity; and,

WHEREAS, these historical artifacts should be collected, preserved, and displayed as a matter of civic price and educational interest;

NOW, THEREFORE, the City of Doraville does hereby designate and establish the City of Doraville Library as a depository for the accumulation, preservation, and display of all articles of historical significance, tending to evidence the cultural, political, social and economical development of the City and of the surrounding areas.

In Witness Whereof, I have hereunto set my hand and caused the Seal of the City of Doraville to be affixed. This 3rd day of July 1978

Jesse E. Norman
MAYOR

BY THE MAYOR

City Clerk

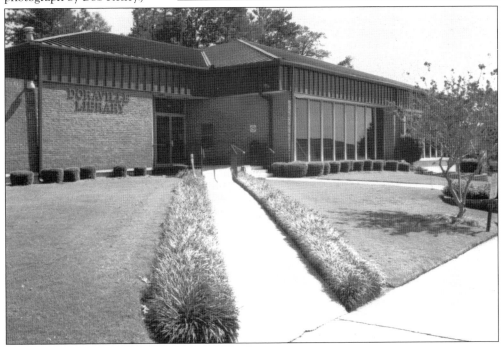

McDonald's Corporation
Atlanta Regional Office
5901 Peachtree-Dunwoody Road
Suite C-500
Atlanta, Georgia 30328

July 5, 2005

Ray Jenkins, Mayor
City of Doraville
3725 Park Avenue
Doraville, GA 30040

Dear Mayor Jenkins:

As you know, the McDonald's of Doraville, Georgia's very first McDonald's, has been completely rebuilt and just reopened for business June 28. Lots of new bells and whistles, as you have seen, and also specifically constructed and designed to appeal to the multi-cultural population in and around Doraville. We at McDonald's are very proud of the results and believe that the residents of Doraville are, as well.

We are planning our Grand Re-Opening for Saturday, July 16, to include The People Painters from 11:00 to 2:00 and a Ronald McDonald Show at 2:00 followed by the official ribbon-cutting at 2:30. If you are available July 16, we would greatly appreciate your participating in the ribbon-cutting and also accepting a donation from McDonald's to one of your city's favorite charities. Regarding the latter, we welcome your recommendations.

Please contact Martha Hunt at 404-292-0986 or mkhunt@mindspring.com to let her know if you will be able to participate with us July 16 and also to let her know which local charity you recommend as the recipient of our "money ribbon" that afternoon.

In the meantime, I am enclosing a special "Be Our Guest" invitation for you in appreciation of your support. I enjoyed meeting you at the restaurant the other day and look forward to the possibility of seeing you again very soon!

Sincerely,

Darlene McCannon

Darlene McCannon
Operations Manager
McDonald's of Doraville, GA

McDonald's brought fast-food dining to Doraville over 50 years ago. The first McDonald's in Georgia, store No. 338, opened on Buford Highway in November 1961, and as the letter at left indicates, was completely torn down and rebuilt in 2005. There are now hundreds of McDonald's located throughout Georgia, but the store on Buford Highway will always have the distinction of being the first one in the state! (Left, courtesy of Lou Jenkins; below, photograph by Bob Kelley.)

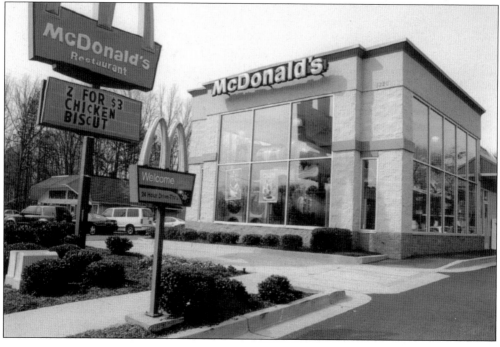

When the White Pine trailer court opened in Doraville after World War II, it was the only trailer court in DeKalb County. The 3.5-acre park could hold up to 50 trailers and was consistently filled with tourists hailing from every state in the country and Canada. To entice guests, owner Roy Munday was always making improvements on the conveniences and facilities. (Courtesy of Doraville Library.)

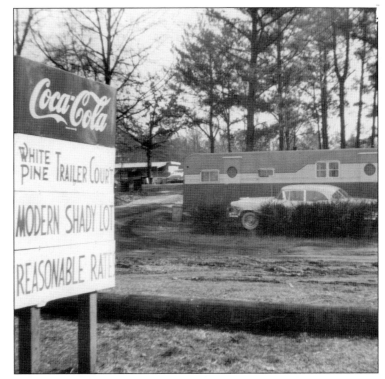

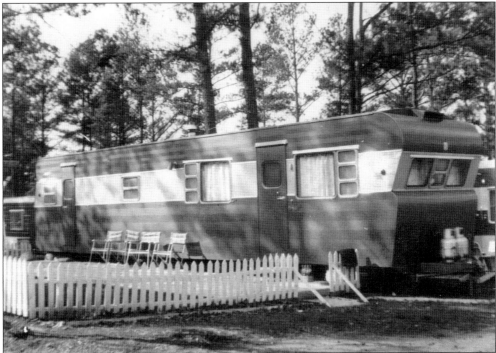

White Pine Trailer Park's location—on New Peachtree Road, east of the Doraville First Baptist Church—gave visitors easy access to Doraville, the historical sites in and around Atlanta, and the rolling Appalachian foothills of North Georgia. (Courtesy of Doraville Library.)

John Harwell ("Bud") Maloney was the grandfather of Doraville resident John Maloney. He owned the J.H. Maloney Dairy, located on property that became part of the General Motors plant, and delivered milk and dairy products to Doraville and surrounding communities. In addition to the dairy, he ran the Amoco service station in old downtown Doraville. (Courtesy of John Maloney.)

In the 1930s and 1940s, drivers traveled on lonely stretches into and out of Doraville. That changed with the construction of the GM plant and the subsequent new residents who came here to work for the automobile giant and other new businesses. Within a few years, the area had grown into a vibrant city. (Courtesy of Doraville Library.)

In the past 20 years, diversity has exploded throughout the Doraville area, with growing ethnic communities giving rise to its international flavor. Some of the finest Asian, Vietnamese, Thai, Japanese, Mexican, and Indian cuisine in the metro Atlanta area is found within Doraville's city limits. The different communities actively give back to the community through special fundraising events like the Tea Walk (pictured above), which is sponsored by the Center for Pan Asian Community Services. (Photograph by Bob Kelley.)

This old license tag, though a bit out of focus, sums up nearly 200 years of blood, tears, laughter, and times good and bad in the little agricultural community that grew into a modern urban city. In Doraville, family roots run deep, and the city of today is the proud result of the pioneer families and their progeny, who made it a good place to live. Now, at the beginning of a new century, the city continues to forge ahead as new families move in and merge with old ones to create future memories and a history of their very own. (Courtesy of Doraville Library.)

DISCOVER THOUSANDS OF LOCAL HISTORY BOOKS
FEATURING MILLIONS OF VINTAGE IMAGES

Arcadia Publishing, the leading local history publisher in the United States, is committed to making history accessible and meaningful through publishing books that celebrate and preserve the heritage of America's people and places.

Find more books like this at
www.arcadiapublishing.com

Search for your hometown history, your old stomping grounds, and even your favorite sports team.

Fredy Perez
678 799 1493